Mehndi

Coloring for Artists

Skyhorse Publishing

Copyright © 2015 by Skyhorse Publishing
Artwork copyright © 2015 by Shutterstock/krishnasomya (Images: 2–4, 6, 8, 13–16)
Shutterstock/Xarlyxa (Images: 31, 34–39)
Shutterstock/Nadezhda Molkentin (Images: 25, 27, 29, 30)
Shutterstock/alkkdsg (Image: 1)
Shutterstock/Drakonova (Images: 5, 17)
Shutterstock/Vera Holera (Images: 7, 9)
Shutterstock/Panteleeva Olga (Image: 10)
Shutterstock/Annareichel (Image: 11)
Shutterstock/Julia Snegireva (Images: 18, 23, 33)
Shutterstock/Vlada Young (Image: 19)
Shutterstock/Rosapompelmo (Image: 20)
Shutterstock/photo-nuke (Images: 21, 26)
Shutterstock/Veronique G (Image: 22)
Shutterstock/Iricat (Image: 24)
Shutterstock/solar lady (Images: 32, 40)
Shutterstock/Transia Design (Image: 44)
Shutterstock/kisika (Image: 41)

Skyhorse Publishing books may be purchased in bulk at special discounts for sales promotion, corporate gifts, fund-raising, or educational purposes. Special editions can also be created to specifications. For details, contact the Special Sales Department, Skyhorse Publishing, 307 West 36th Street, 11th Floor, New York, NY 10018 or info@skyhorsepublishing.com.

Skyhorse® and Skyhorse Publishing® are registered trademarks of Skyhorse Publishing, Inc.®, a Delaware corporation.

Visit our website at www.skyhorsepublishing.com.

10 9 8 7 6 5

Library of Congress Cataloging-in-Publication Data is available on file.

Cover design by Rain Saukas
Cover artwork credit: Shutterstock/Transia Design
Text by Arlander C. Brown III

ISBN: 978-1-63450-400-3

Printed in the United States

Mehndi:
Coloring for Artists

You probably remember coloring books from your childhood—simple designs of cartoons, flowers, or trucks. These are not the coloring books of your youth! Now, you can once again enjoy the relaxing and creative activity of coloring and creating art with this beautiful mehndi adult coloring book. This collection of designs is inspired by the age-old tradition of henna tattoos and offers designs for skilled artists and individuals trying to test their creativity.

For over five thousand years, mehndi or henna has served as a symbol of good luck, health, and sensuality in the Arab world and the Indian subcontinent. The plant has been associated with good vibes and provides a connection to an ancient age full of good and bad spirits, Baraka and Jnoun. Generations of women have used a paste made primarily of dried ground henna leaves to cover their hands and feet with designs ranging from simple shapes to intricate geometric patterns designed to ward off evil, promote fertility, and attract good energy.

Mehndi or henna is the application of a temporary form of skin decoration. Practiced originally in India and the Arab world, mehndi decorations became fashionable in the West in the late 1990s, where they have come to be called henna tattoos.

Mehndi in Indian tradition is typically applied during special Hindu weddings and Hindu festivals like Karva Chauth, Vat Purnima, Diwali, Bhai Dooj, and Teej. In Hindu festivals, many women have henna applied to their hands and feet, and sometimes on the back of their shoulders too, and men have it applied on their arms, legs, back, and chest. For women, it is usually drawn on the palm, back of the hand, and on

An ornate mehndi pattern that could be painted on the hands and feet of Hindu brides.

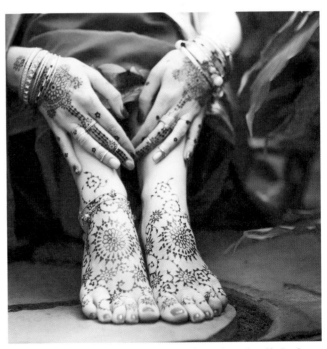

Indian Hindu bride with traditional mehndi designs painted on her feet.

Henna flower used to make pigment for henna tattoos.

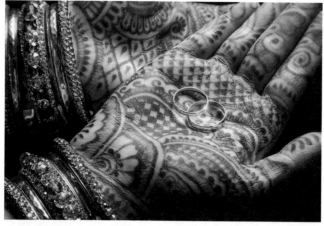
Mehndi designs painted on the palms of the hand where they are more visible because of the lighter skin pigmentation.

feet, where the design will be clearest due to contrast with the lighter skin on these surfaces, which naturally contain less of the pigment melanin. Henna was originally used as a form of decoration mainly for Hindu brides. Muslims of the Indian subcontinent also apply mehndi during their festivals like Eid-ul-Fitr and Eid-ul-Adha.

Now you have the chance to color amazing designs inspired by this age-old tradition. While usually colored only by the wearer's skin tone, the intricate patterns and designs lend themselves to coloring for adults. To make it easier for you to enjoy the relaxing process of coloring, the mehndi designs are printed on only one side of the page, and the pages are perforated so they can be removed from the book. (This also permits you to display your art upon completion.) There are also colored examples of each of the mehndi designs that serve to further inspire your imagination, but this is not paint by numbers. The real fun of coloring is to use your own ideas and colors. So let your mind wander and see how original you can be!

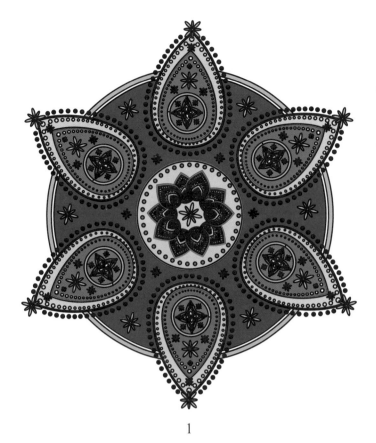

1

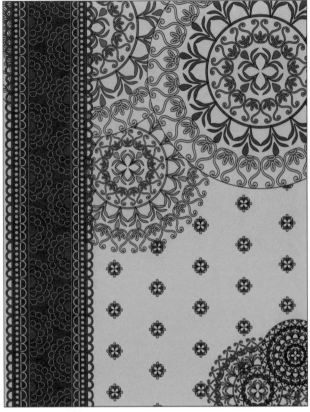

2

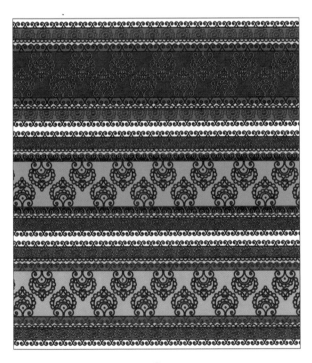

3

4

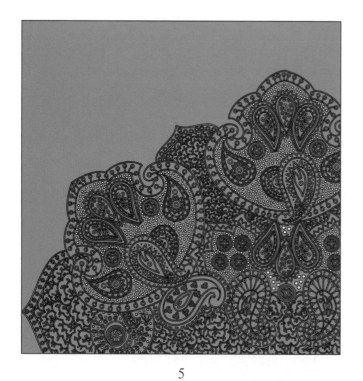

5

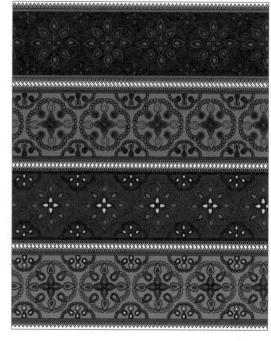

6

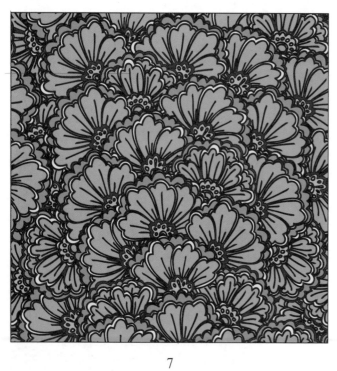

7

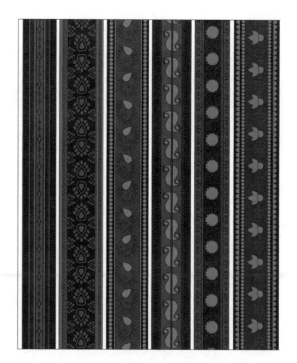

8

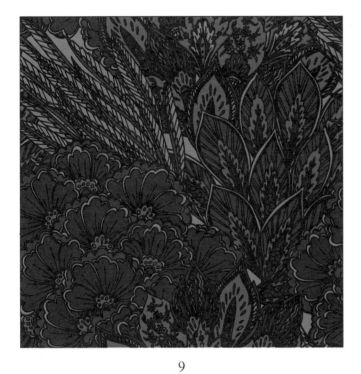

9

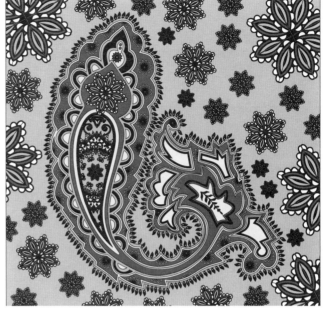

10

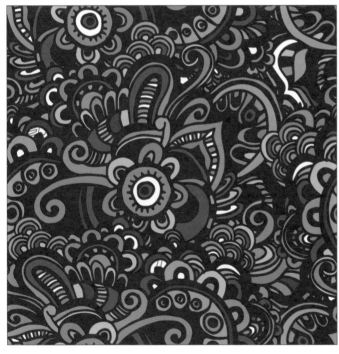

11

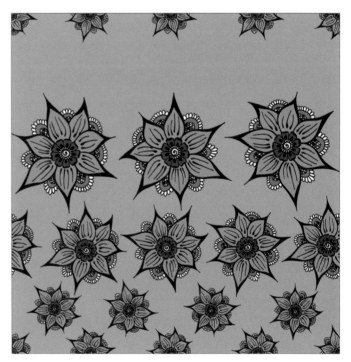

12

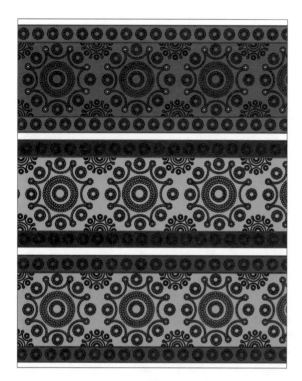

13

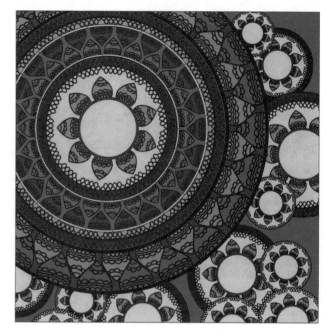

14

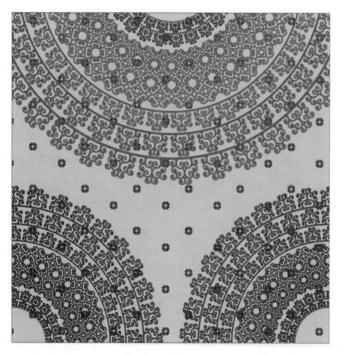

15

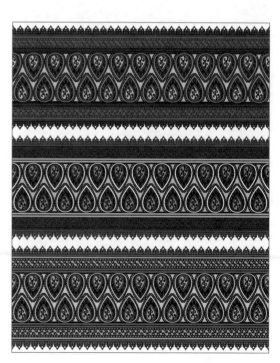

16

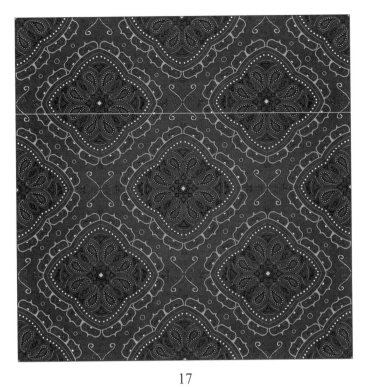

17

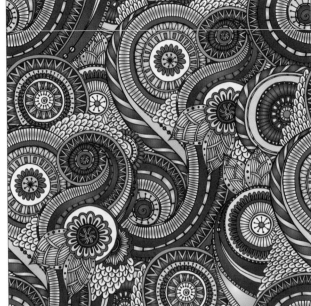

18

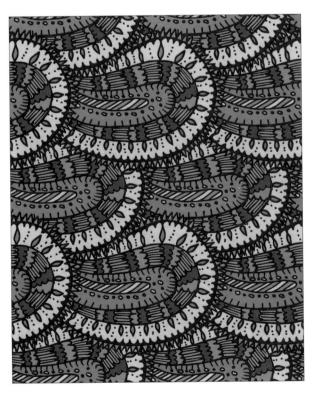

19

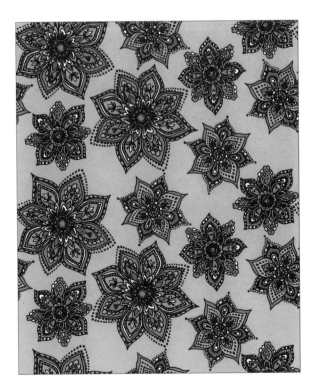

20

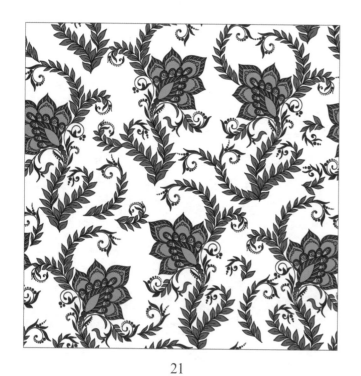

21

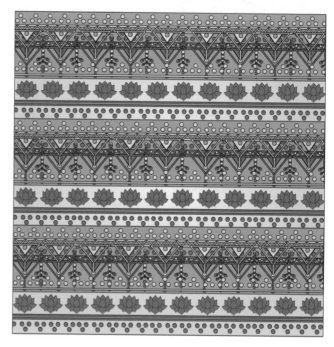

22

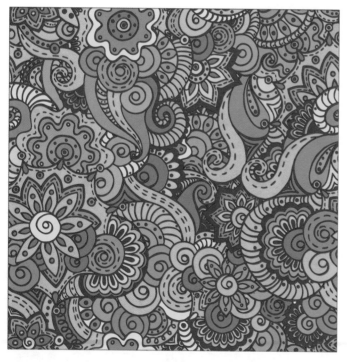

23

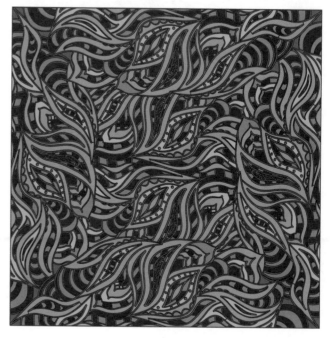

24

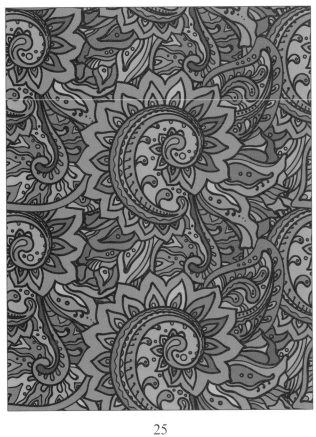

25

26

27

28

29

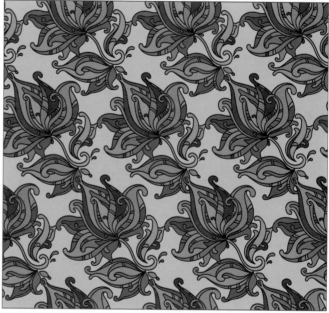

30

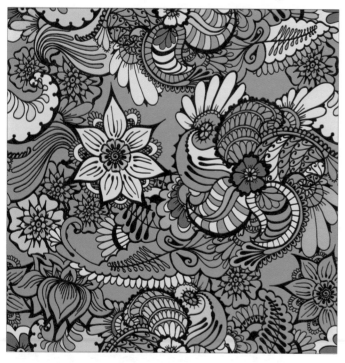

31

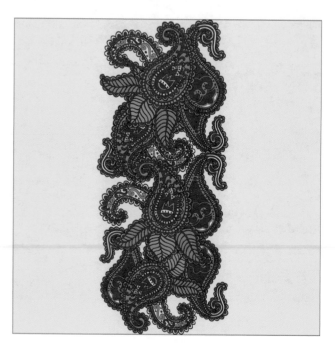

32

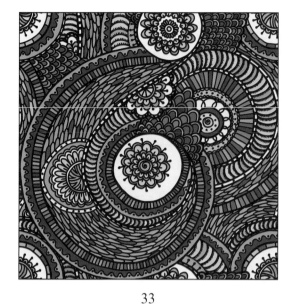

33

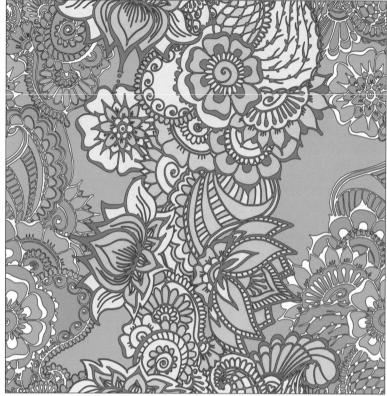

34

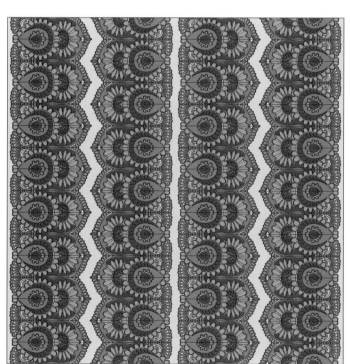

35

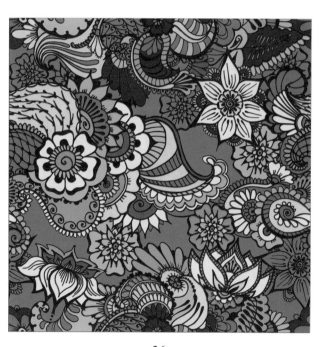

36

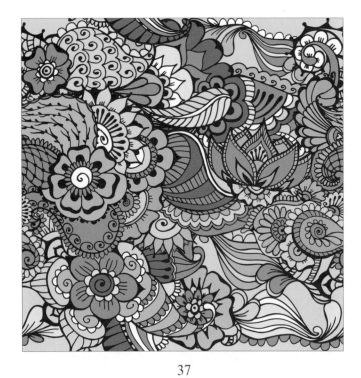

37

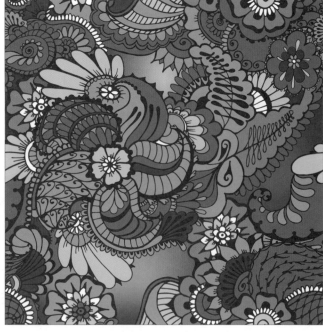

38

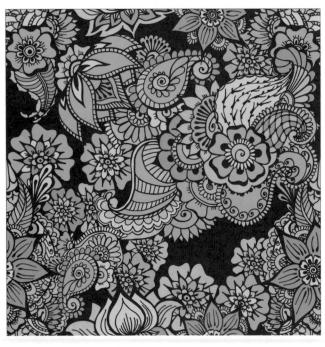

39

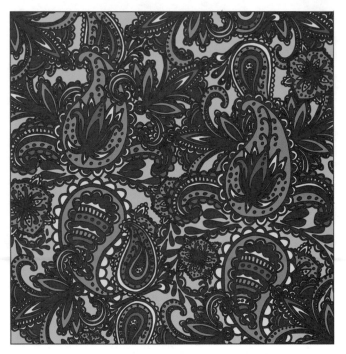

40

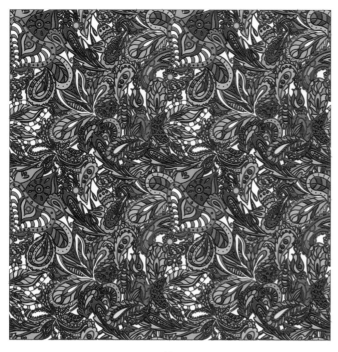

41

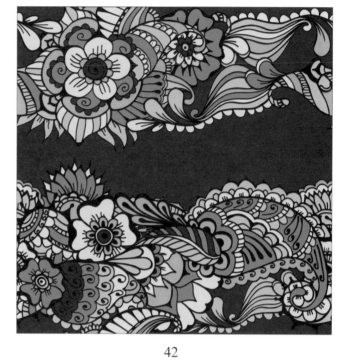

42

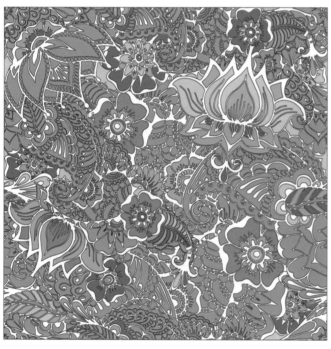

43

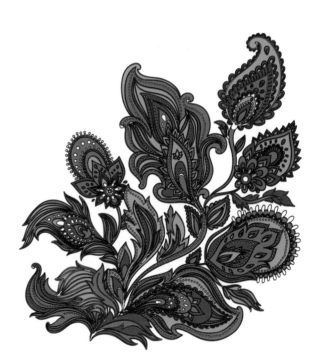

44

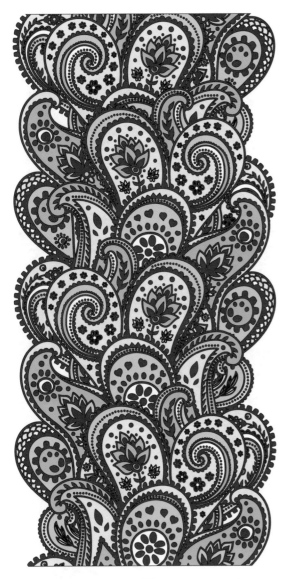

45

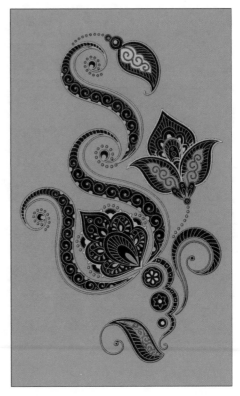

46

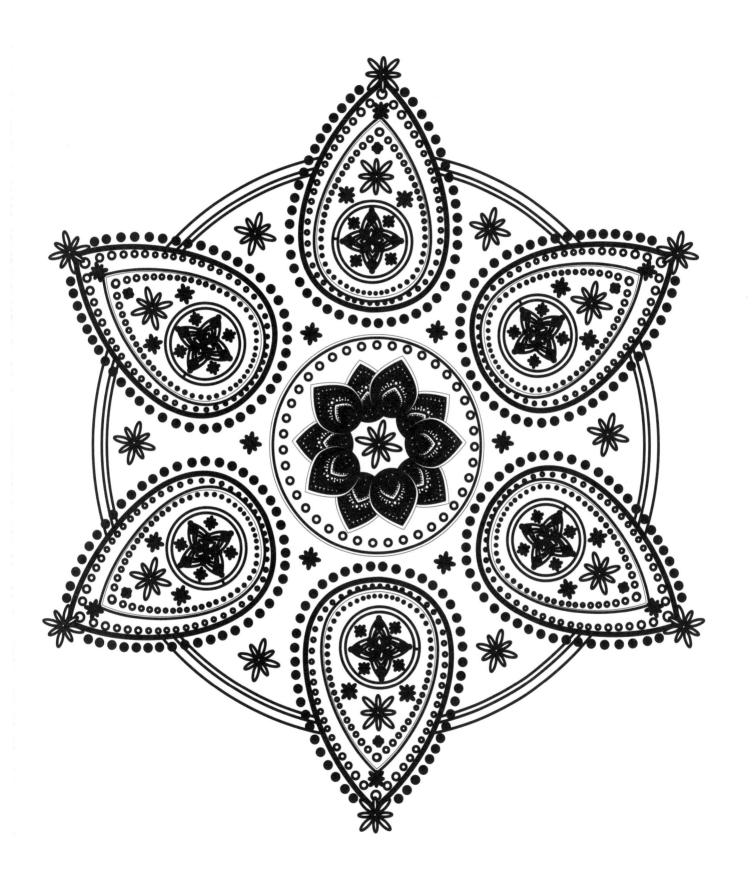

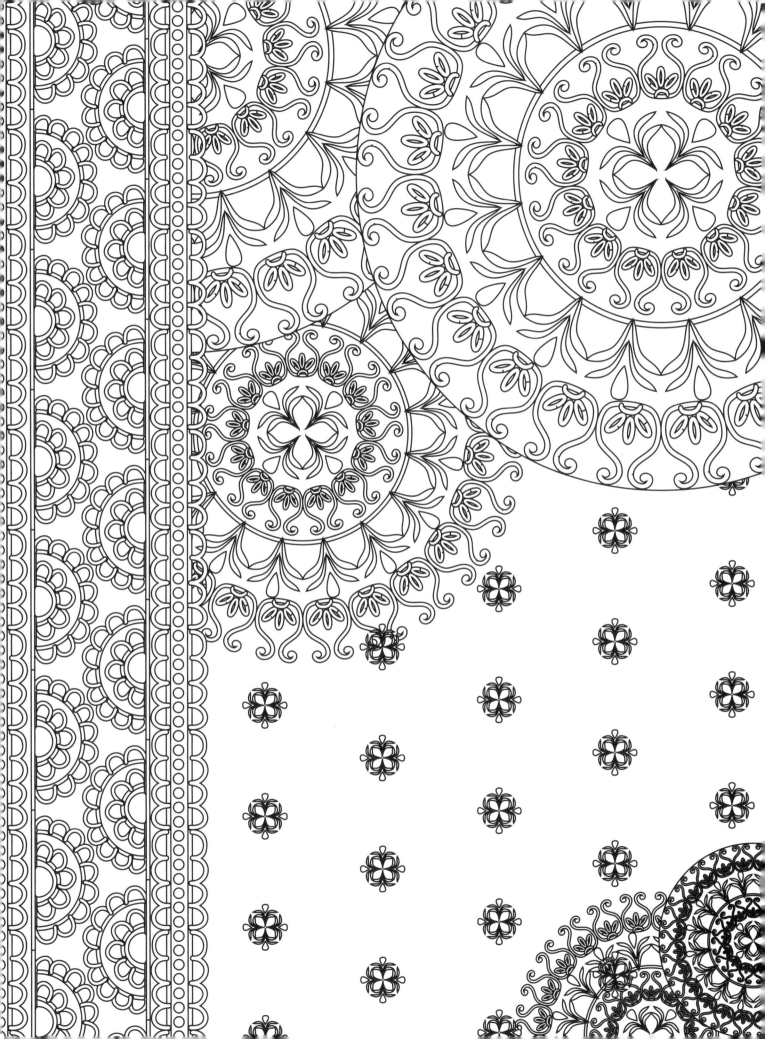

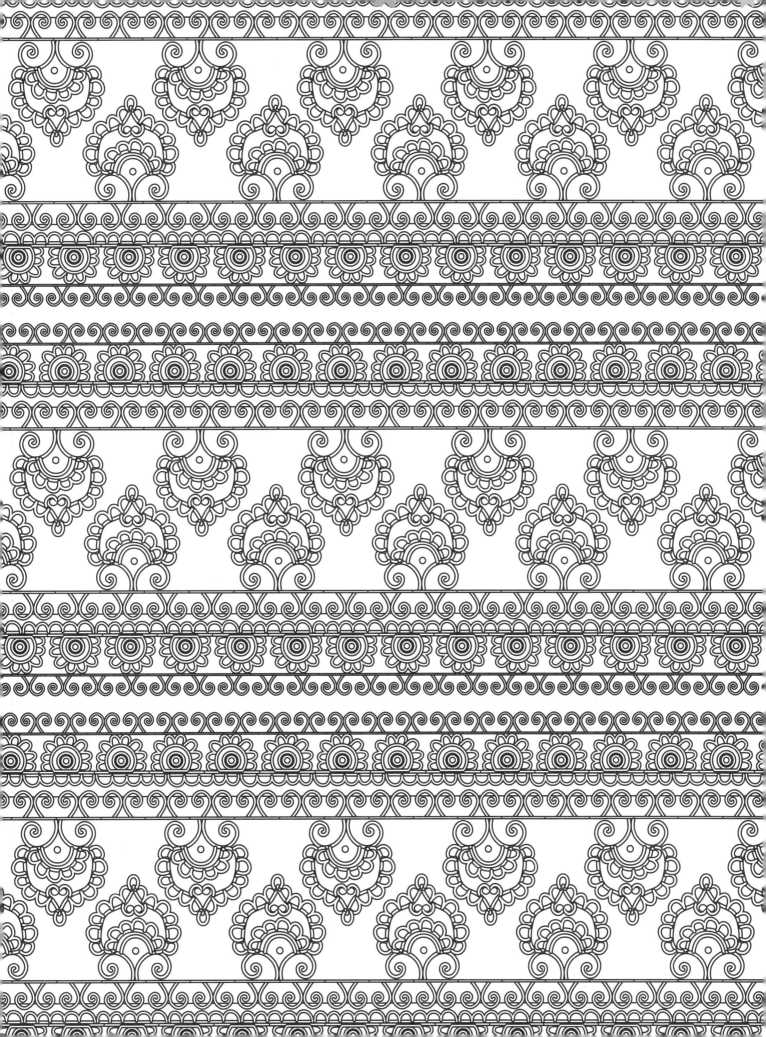

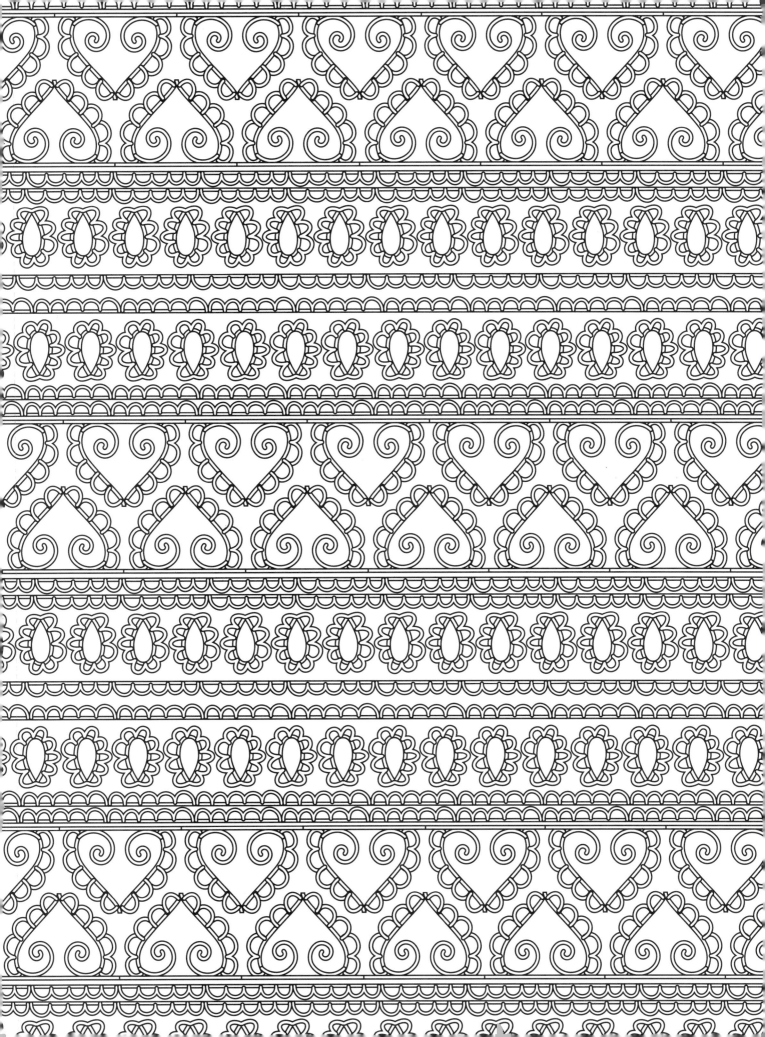

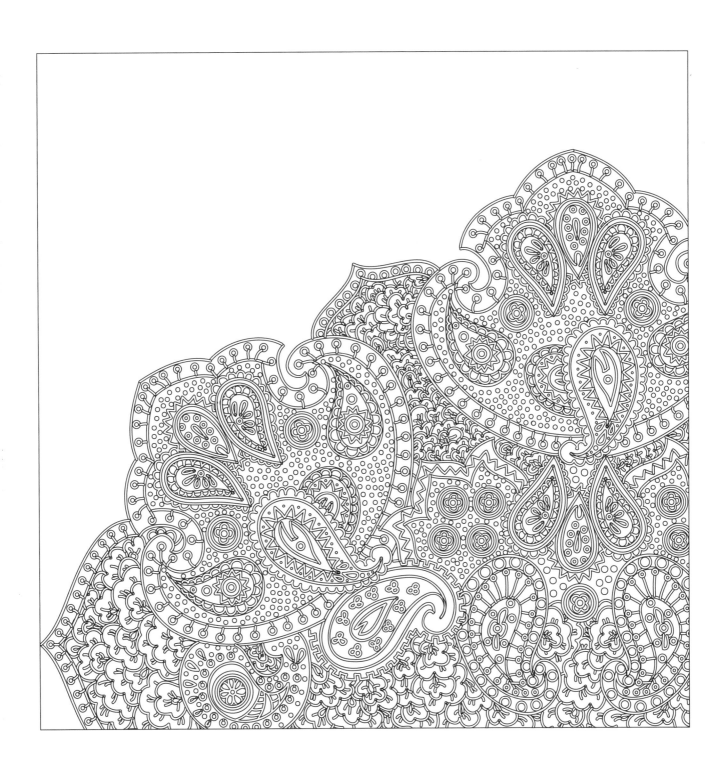

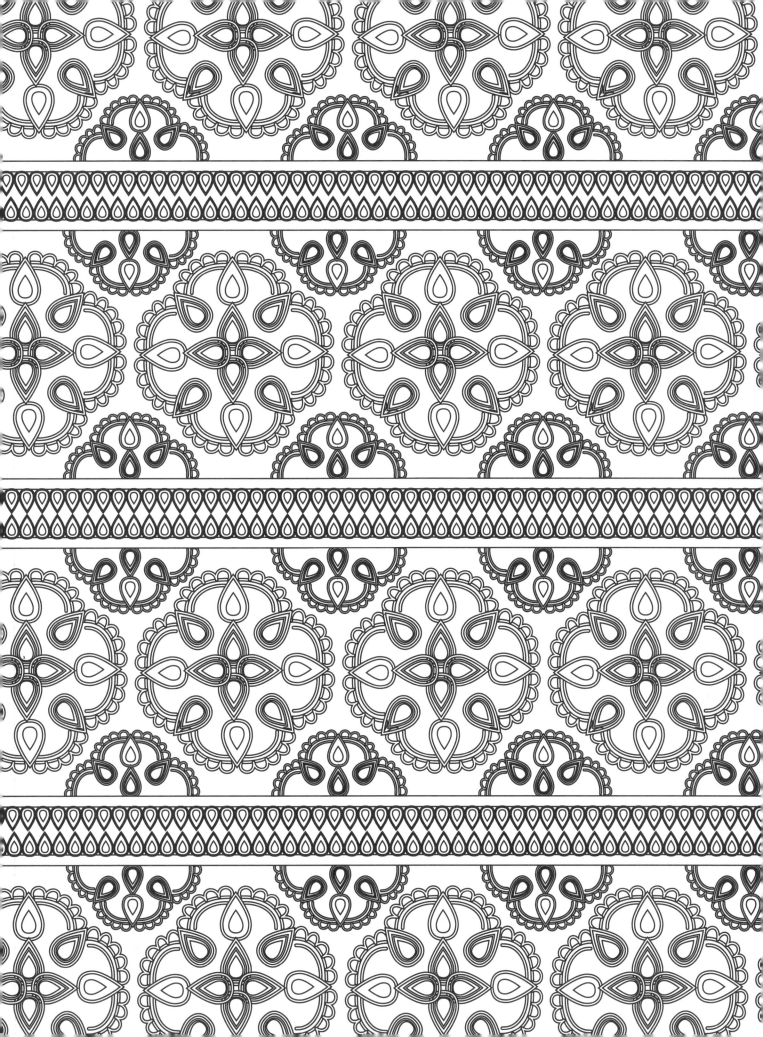

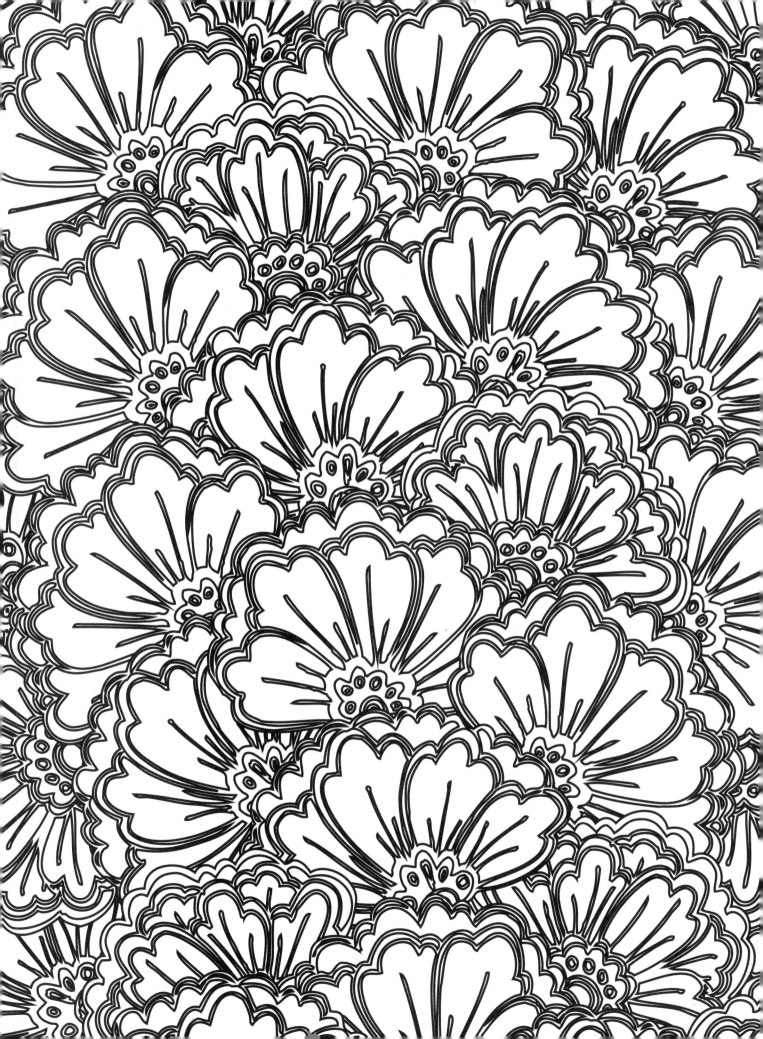

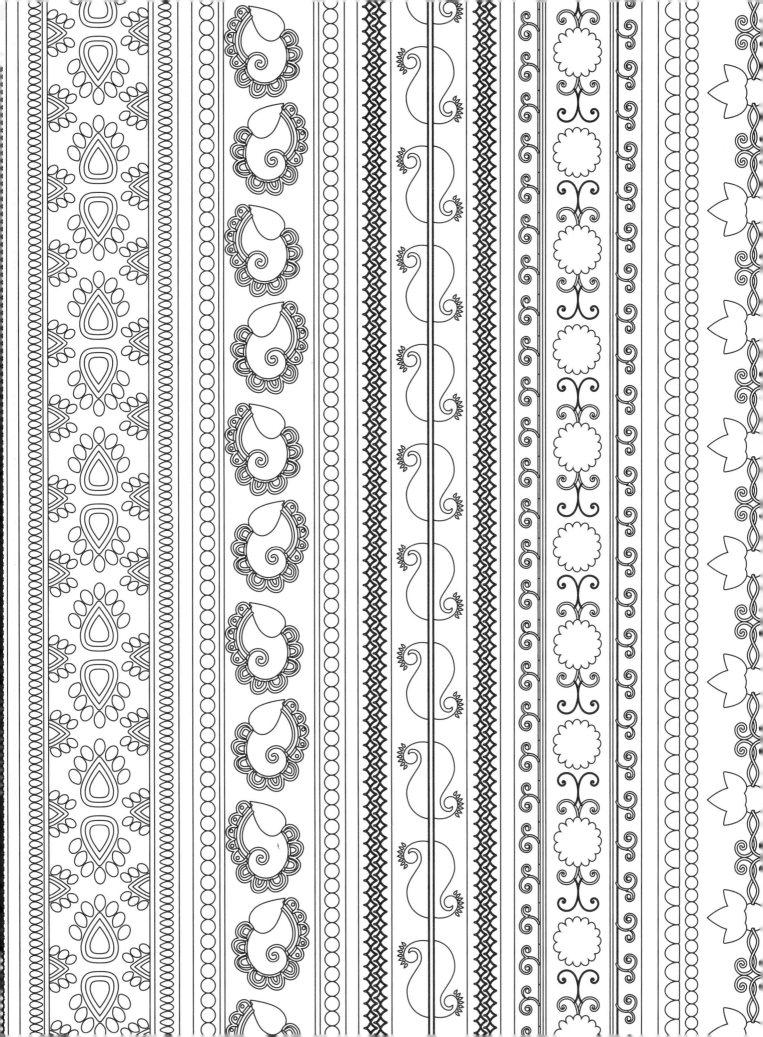

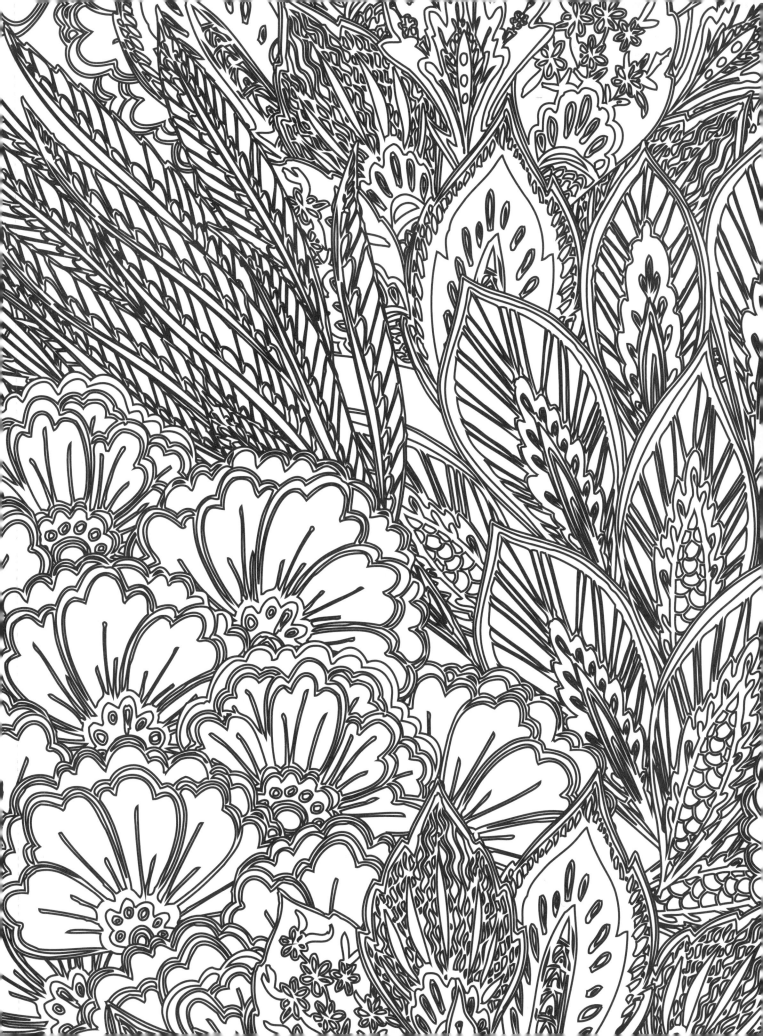

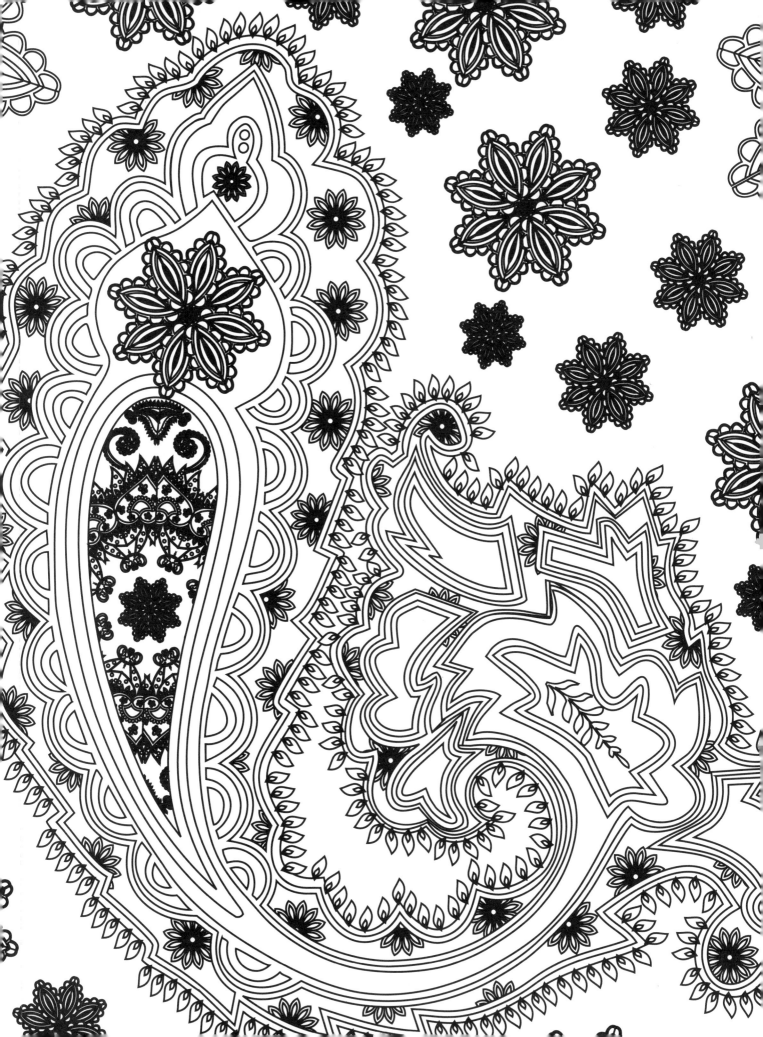

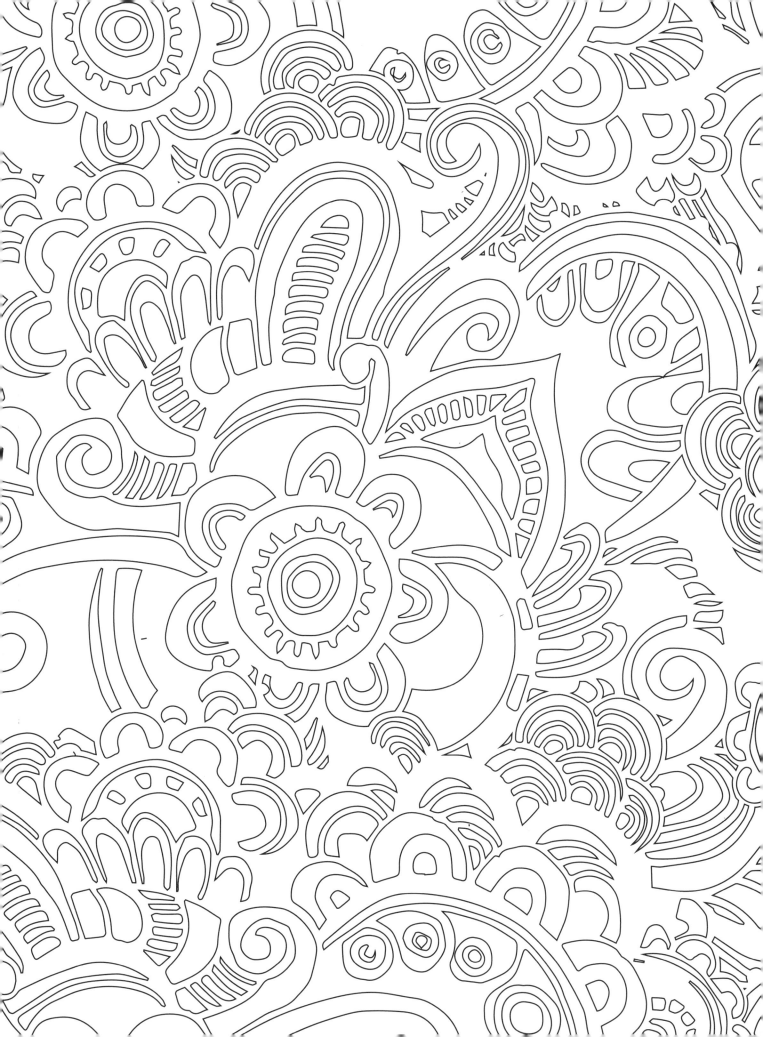

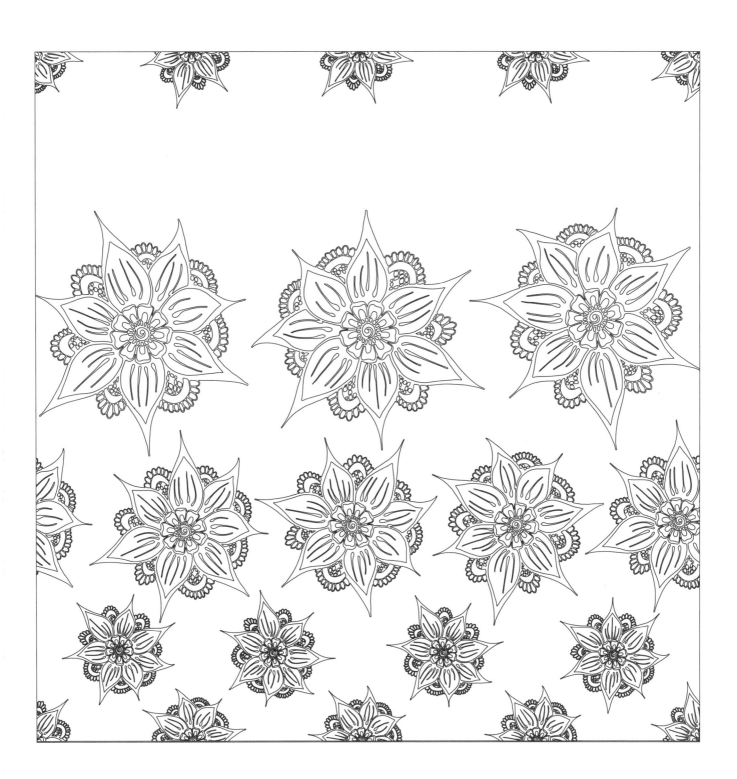

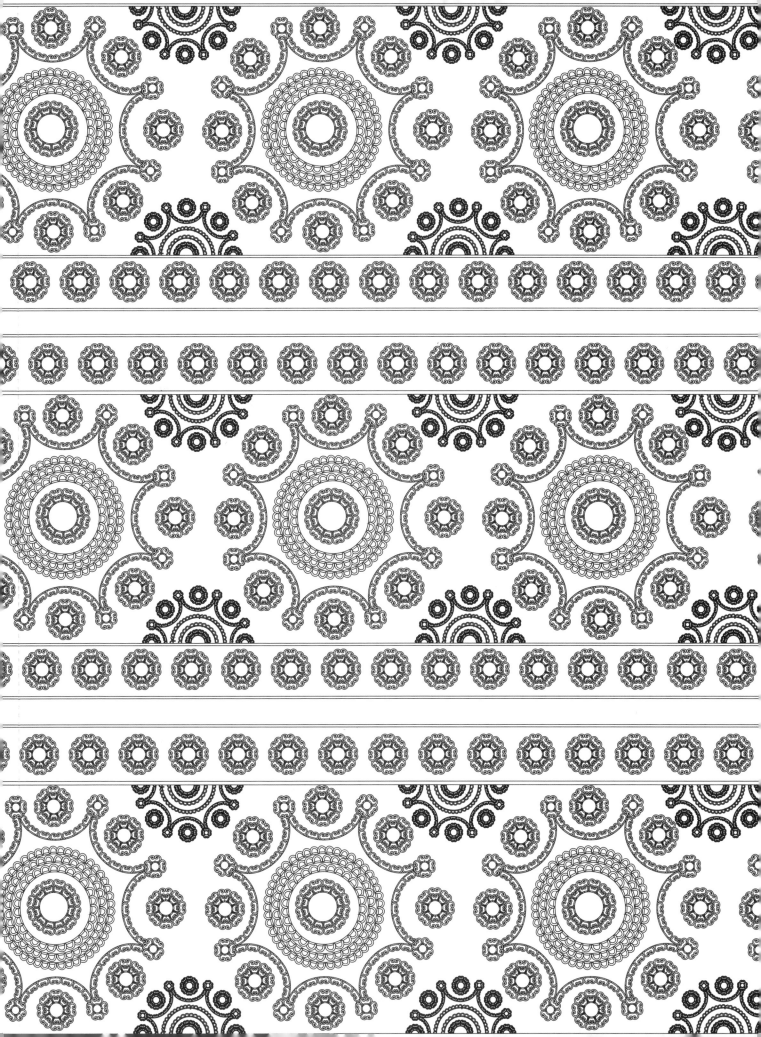

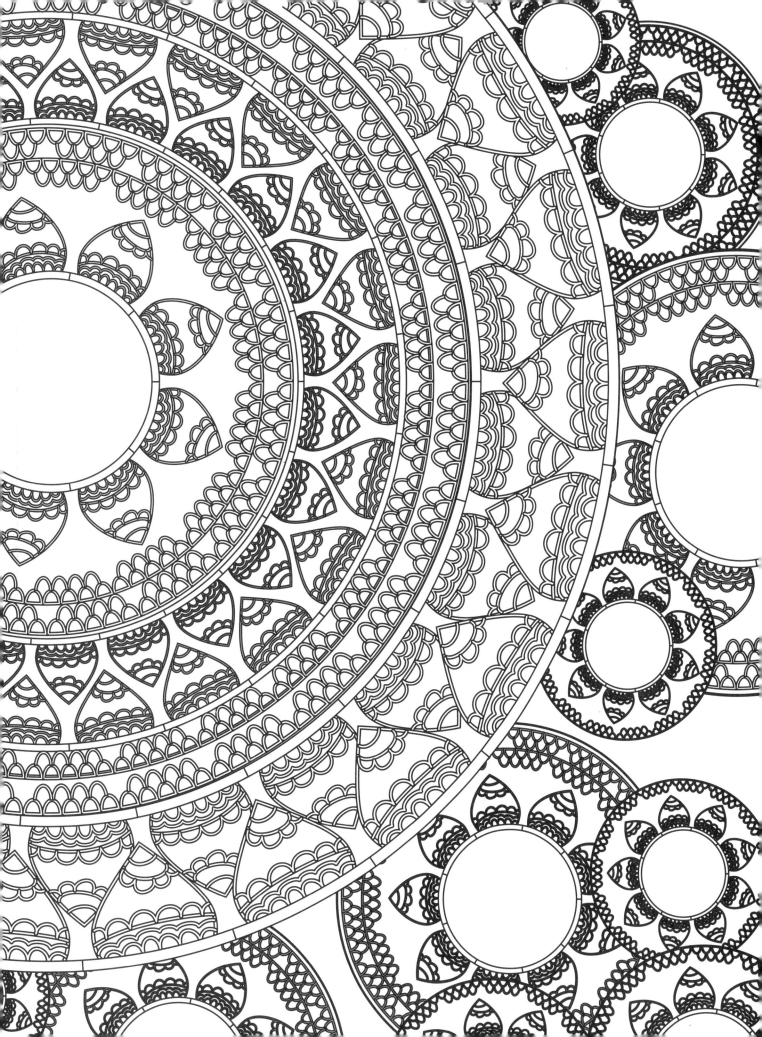

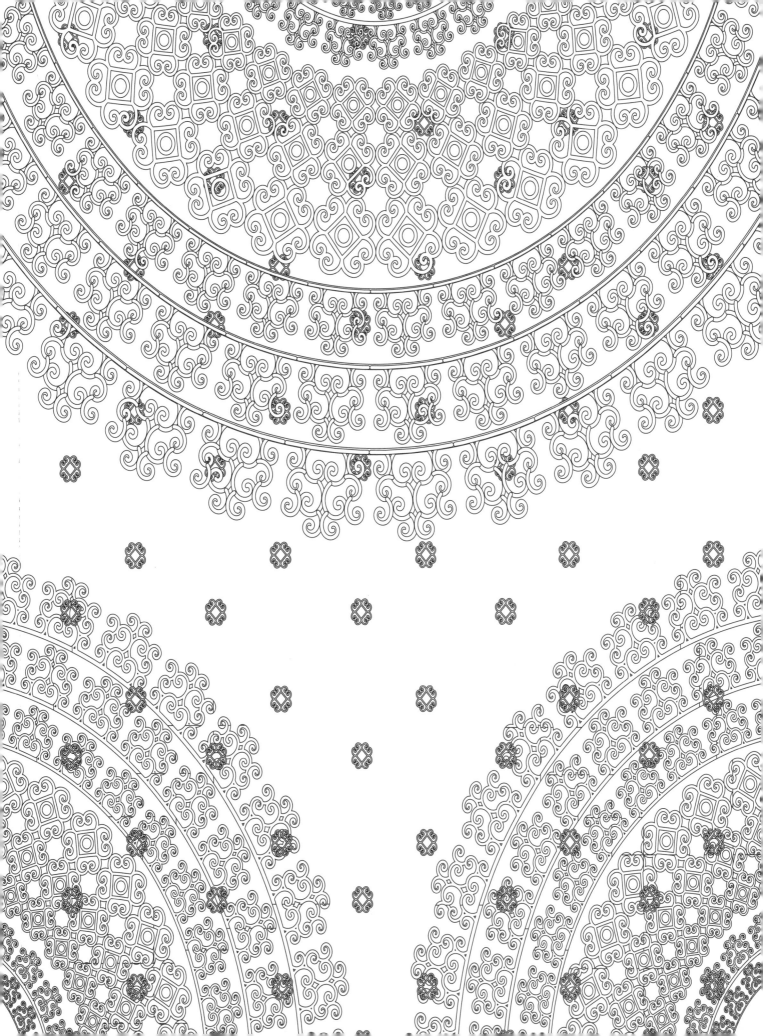

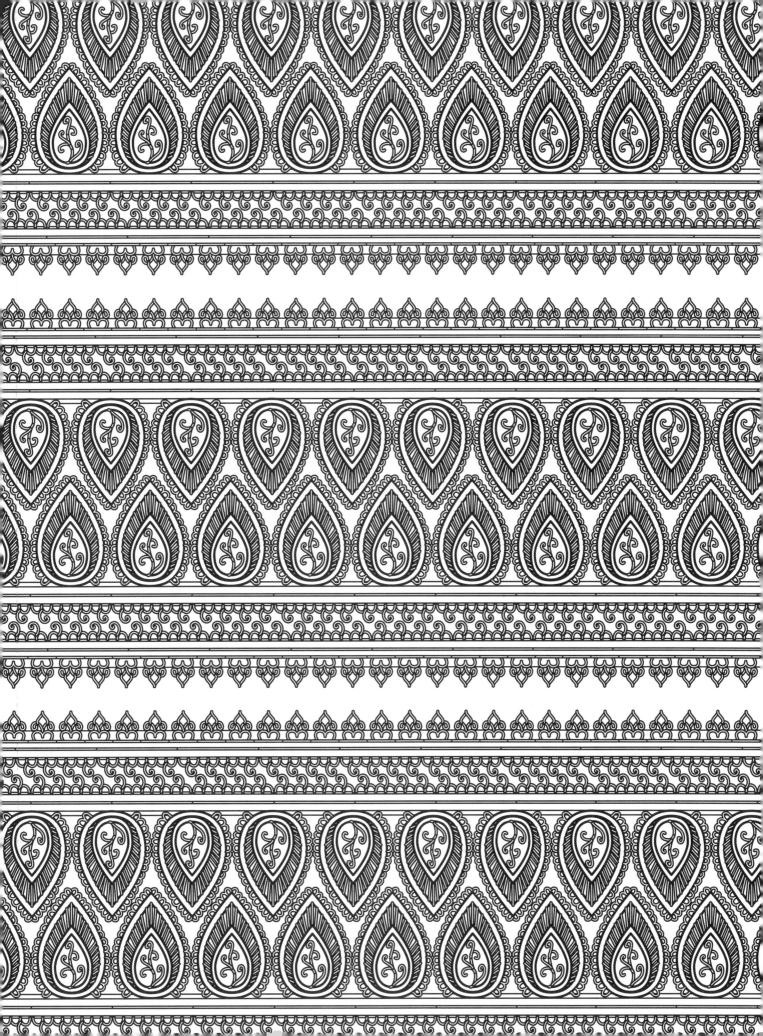

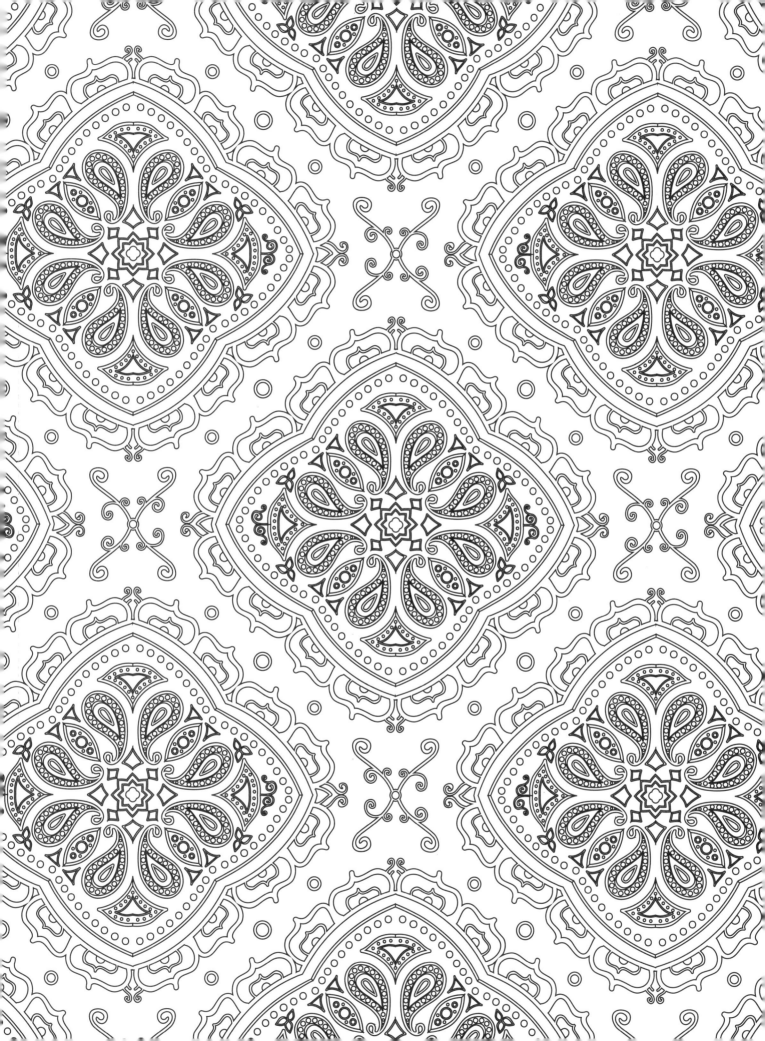

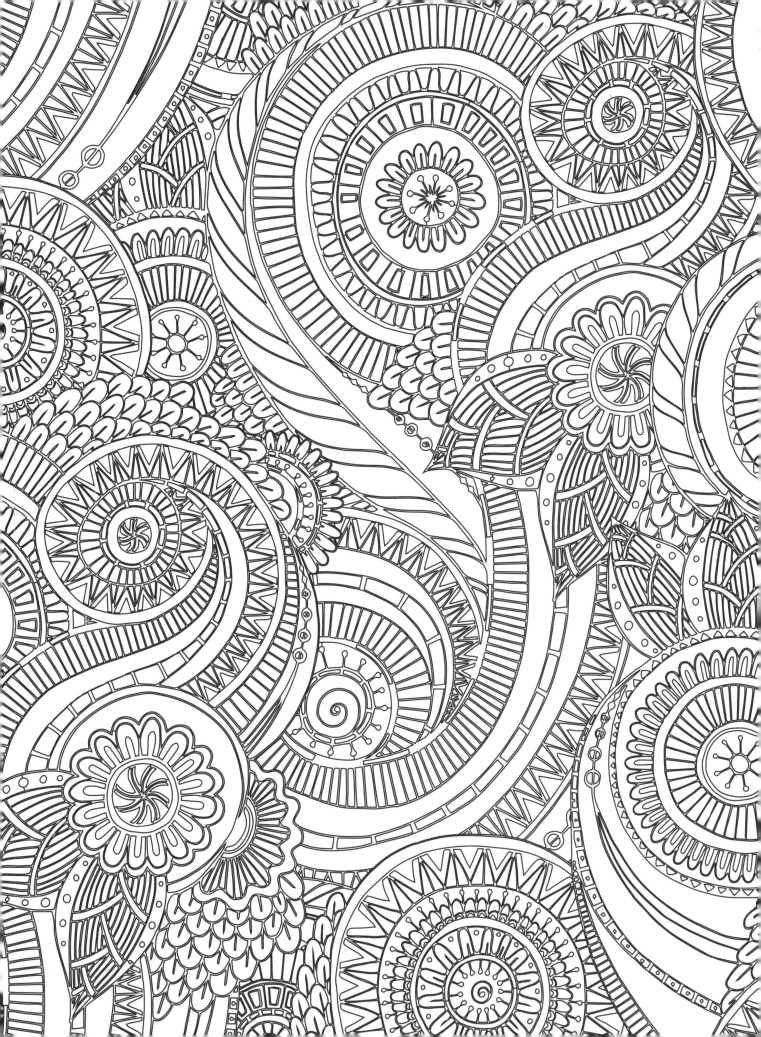

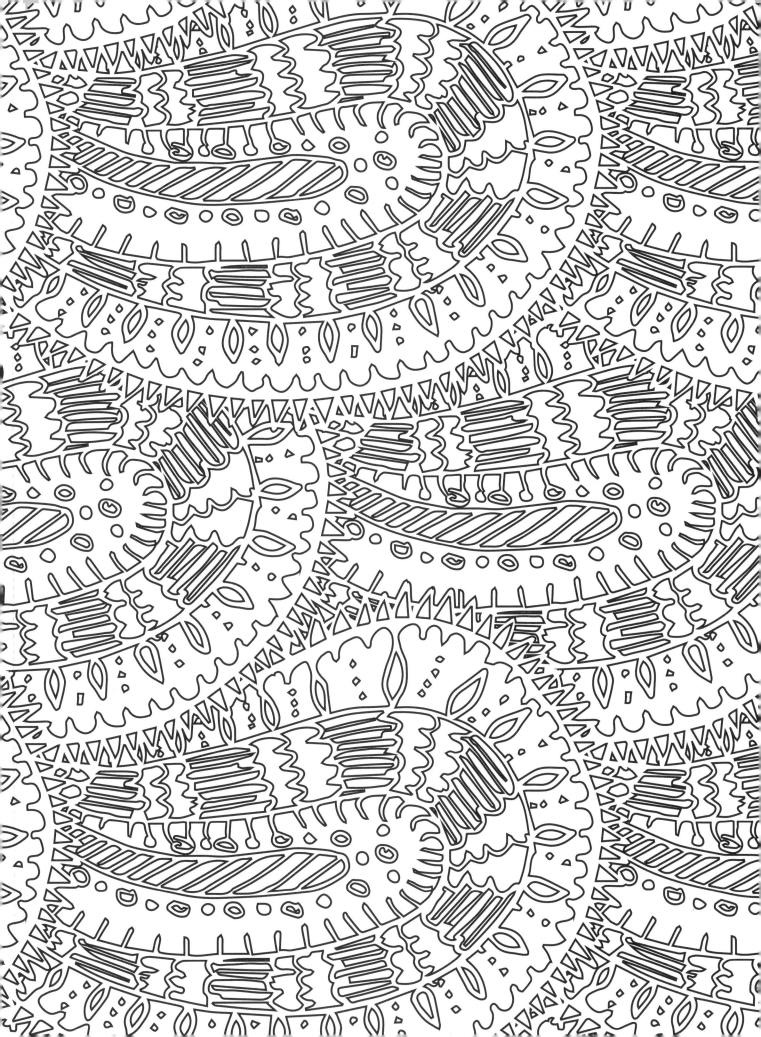

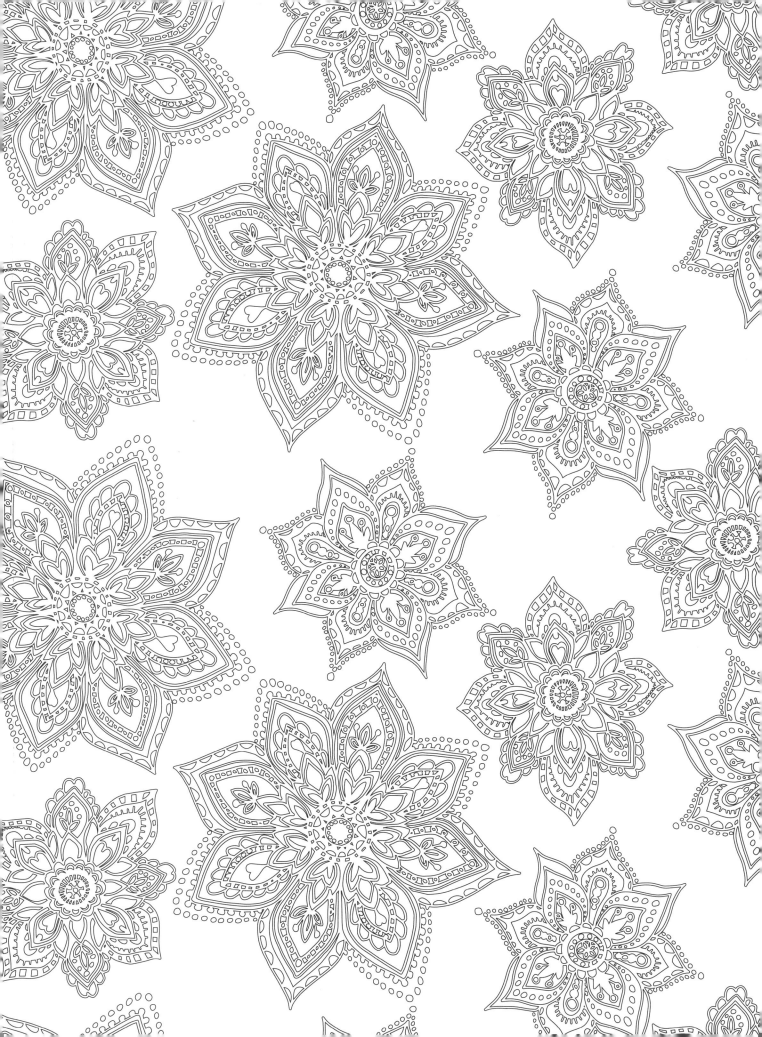

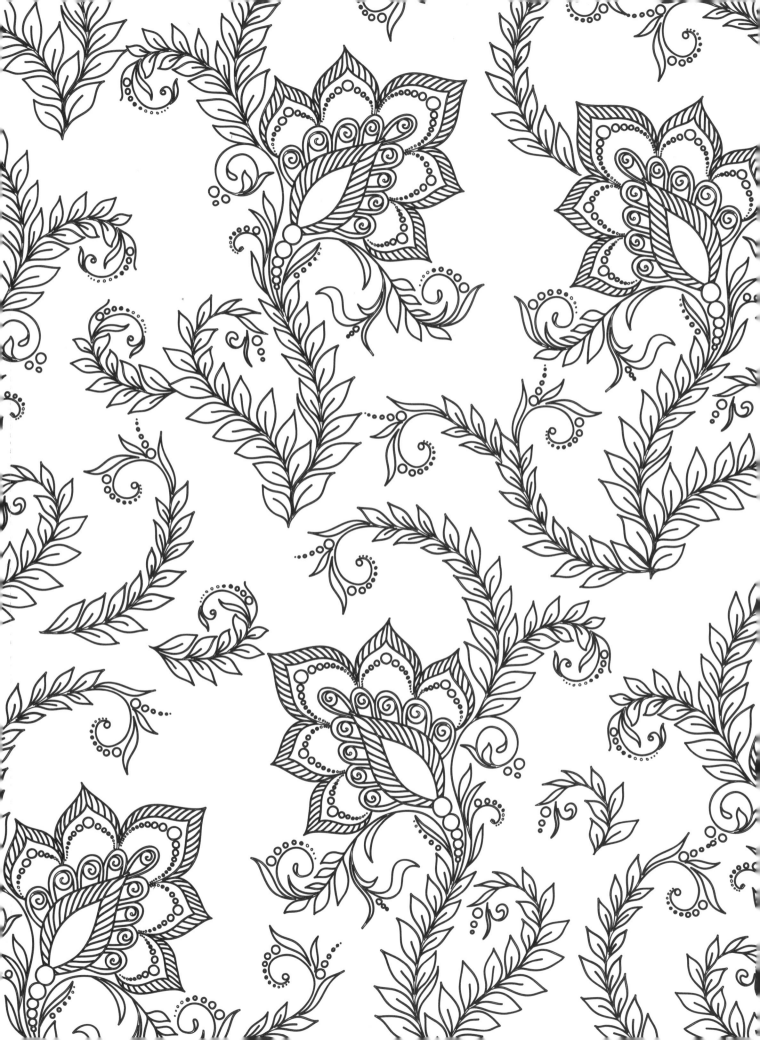

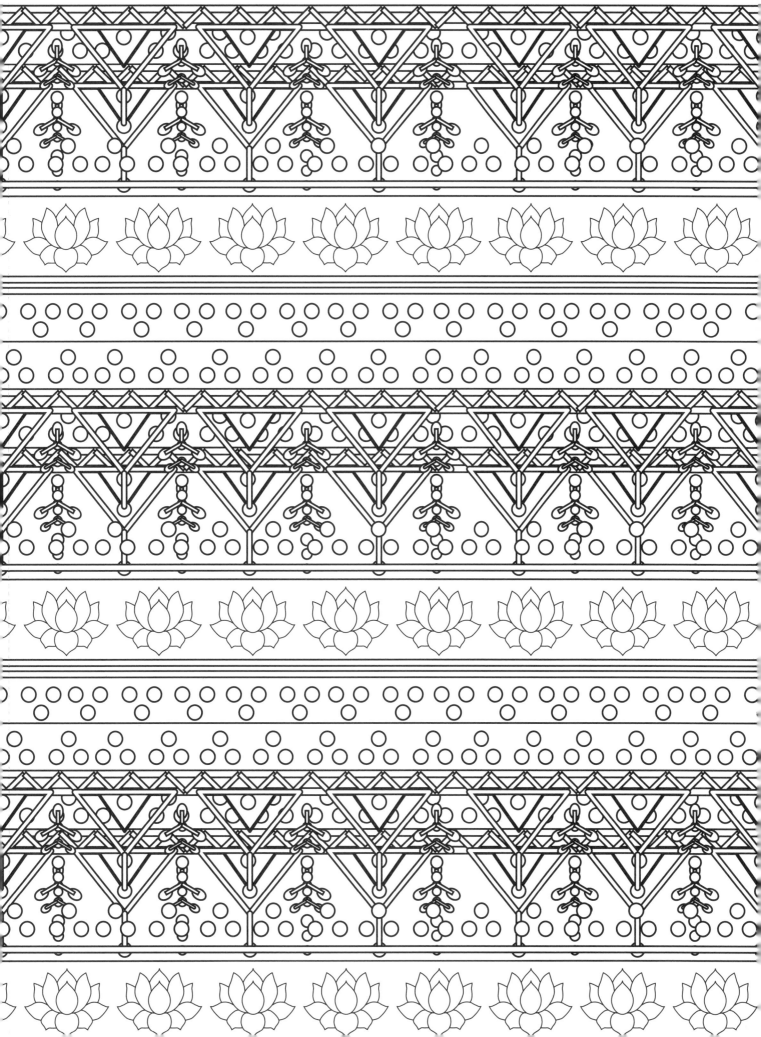

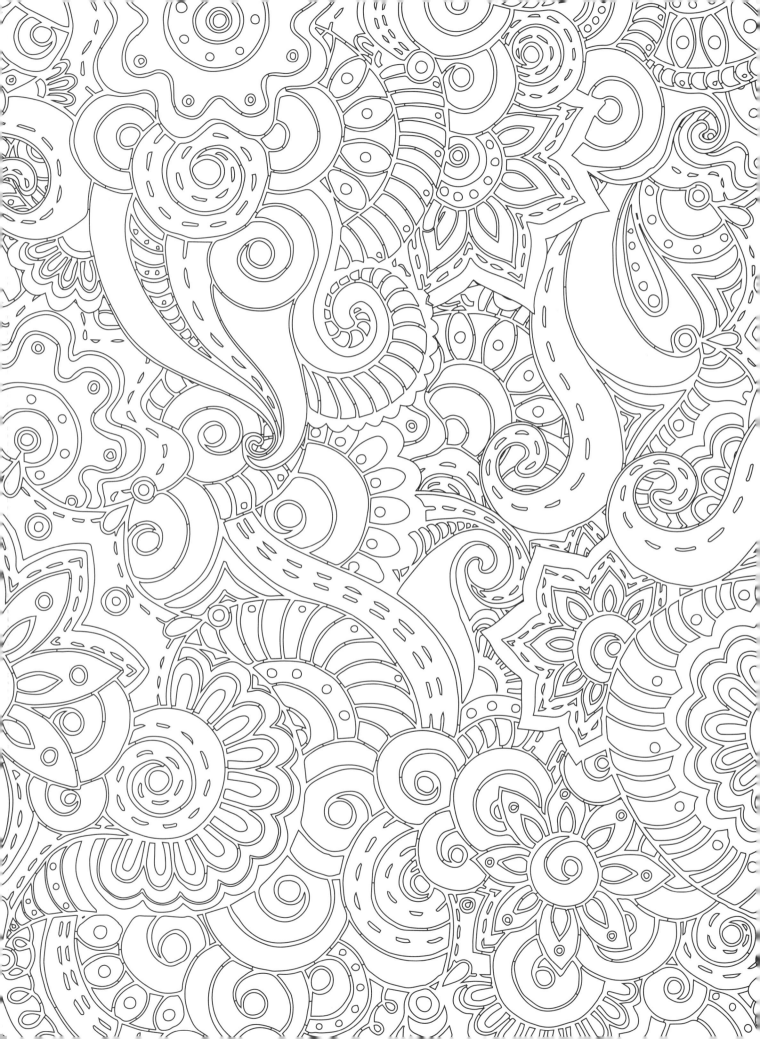

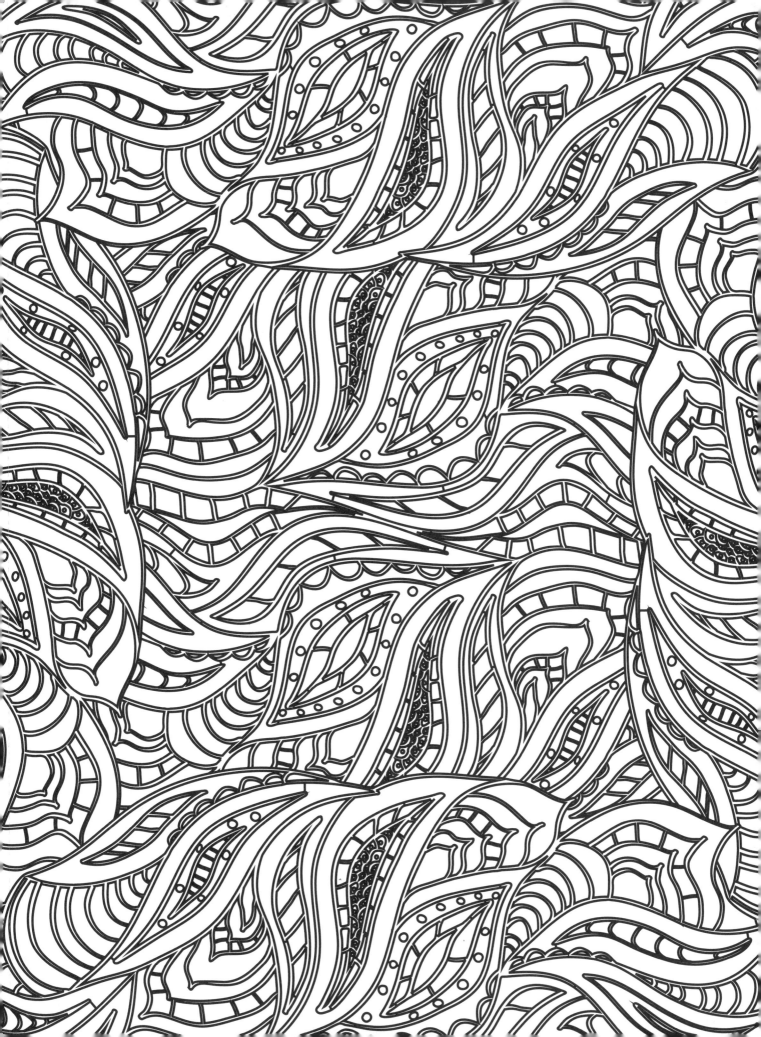

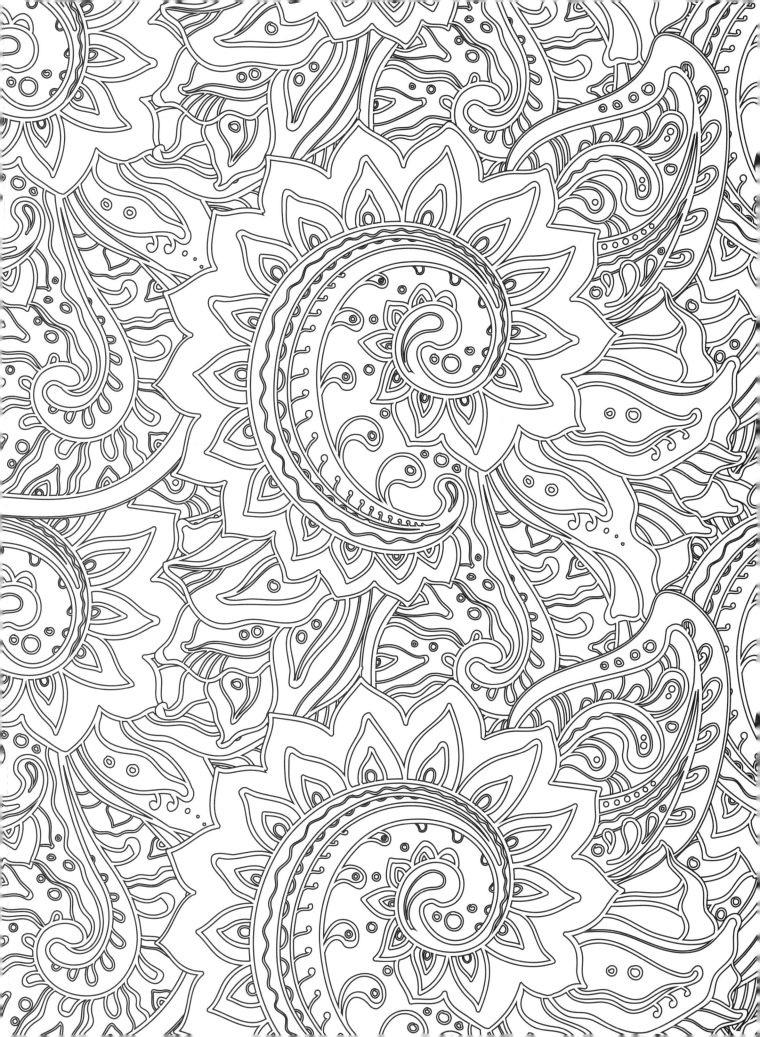

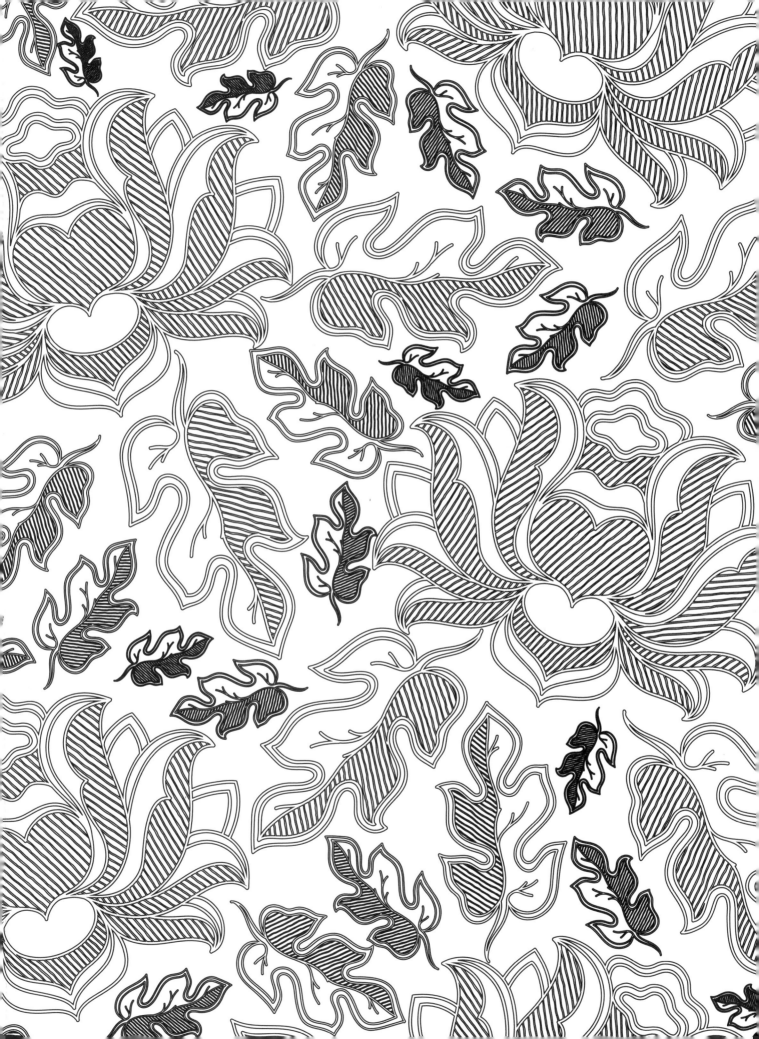

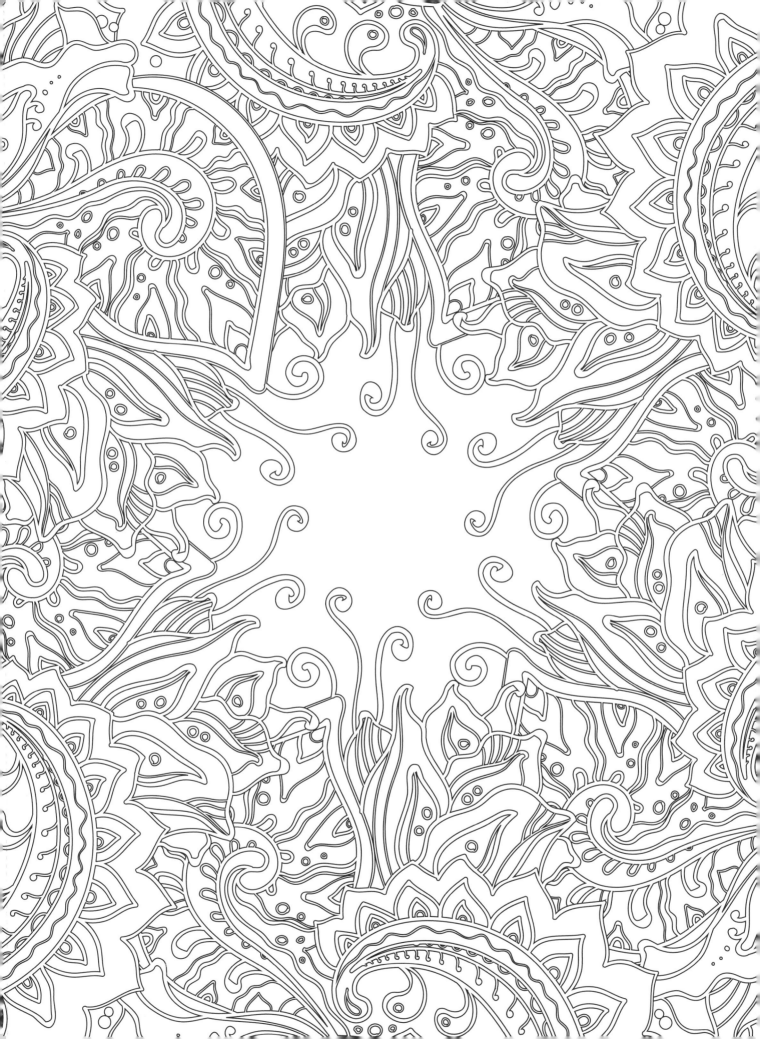

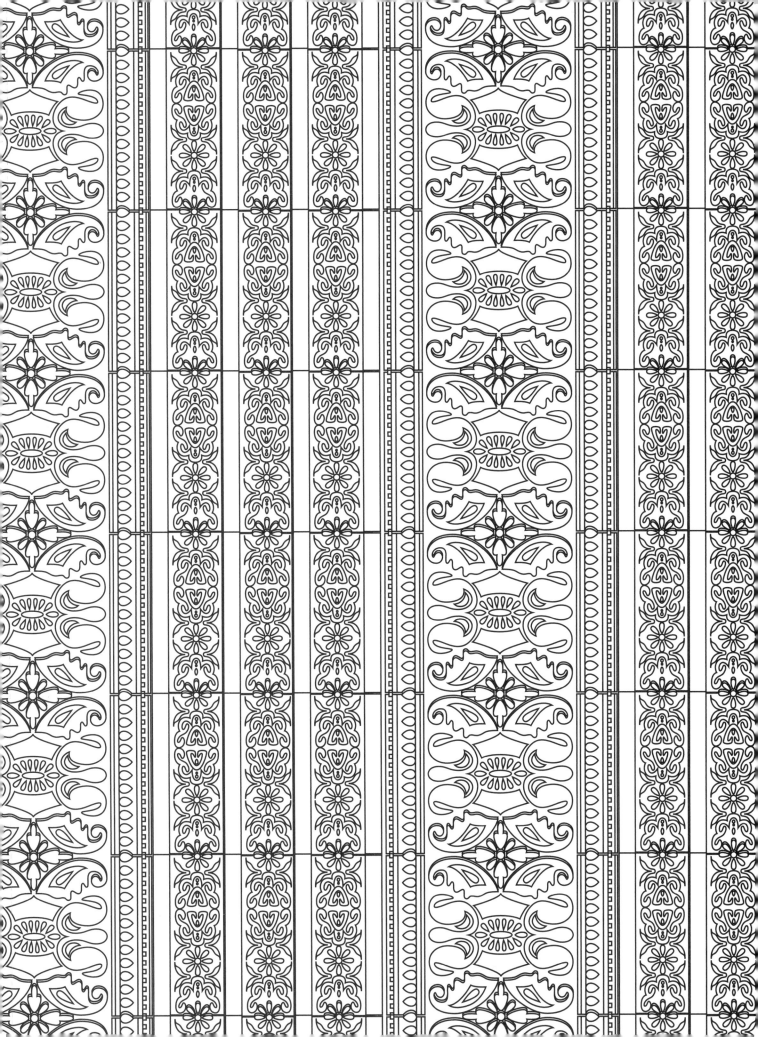

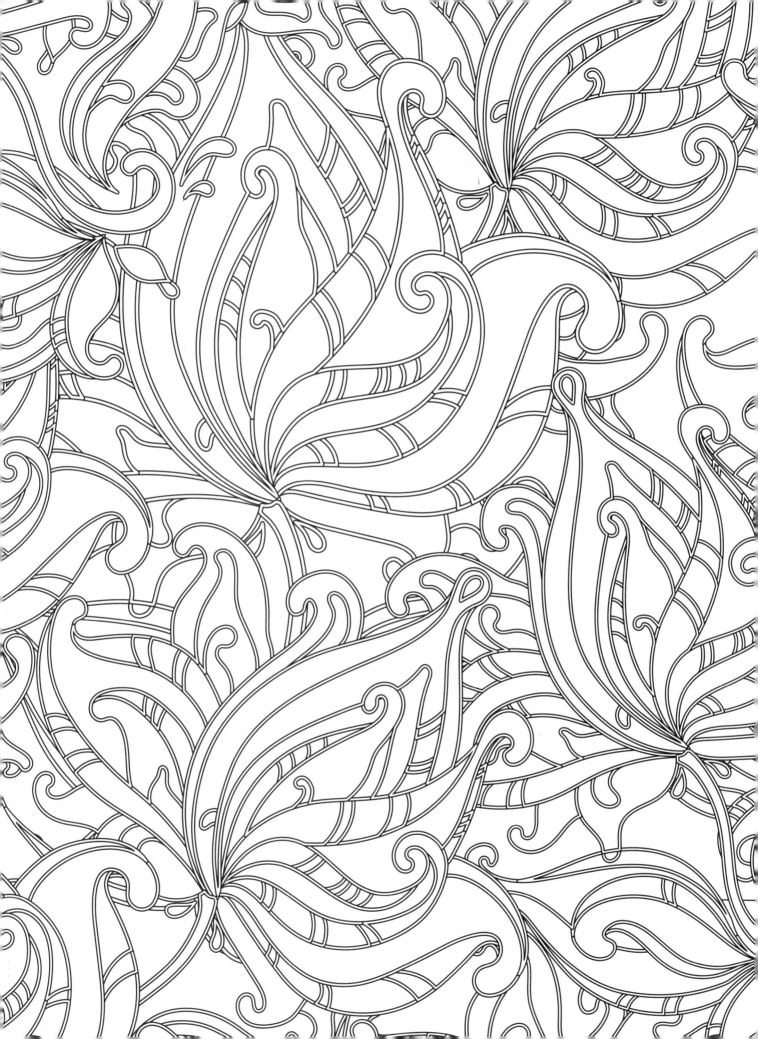

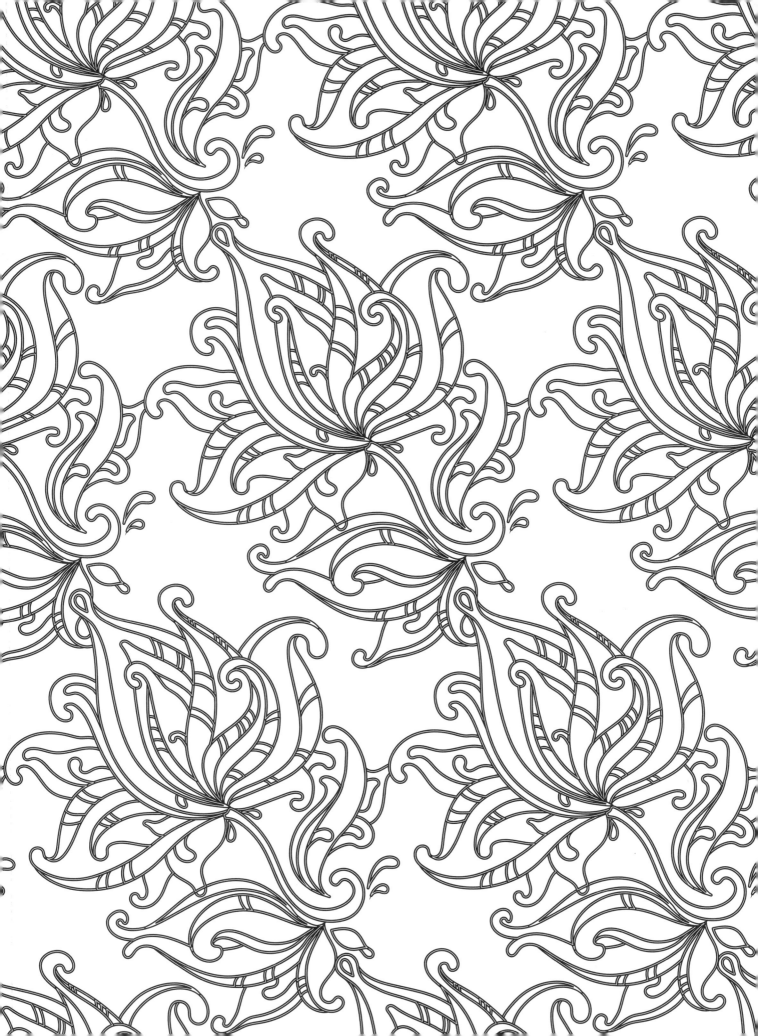

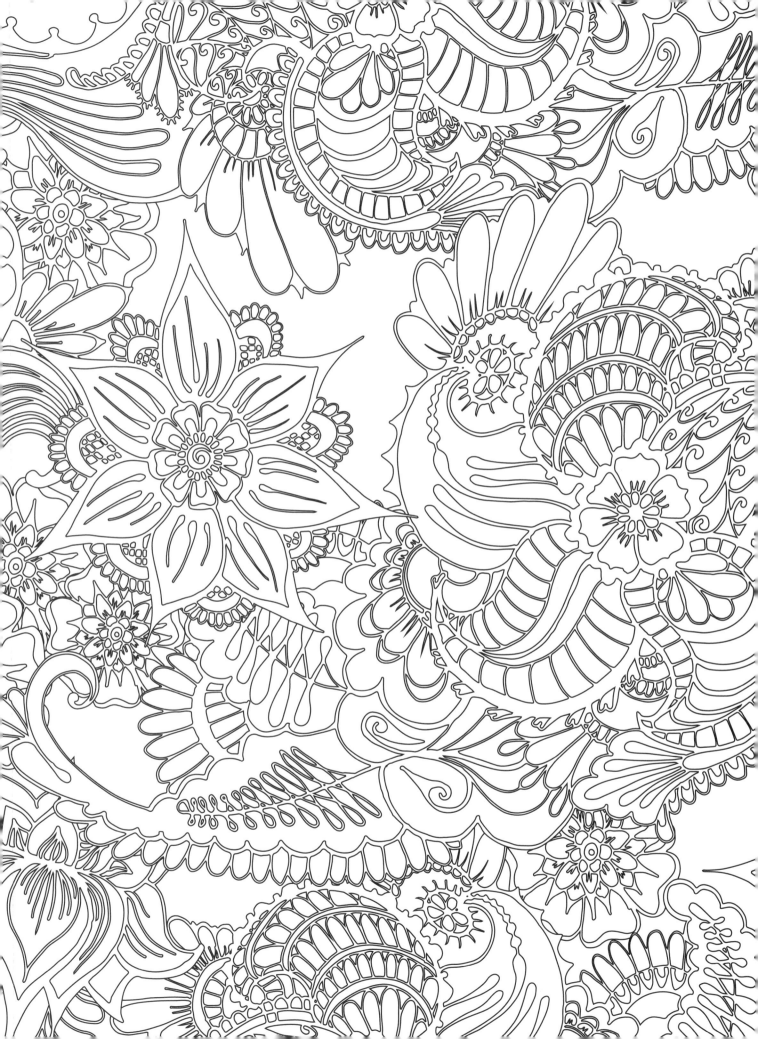

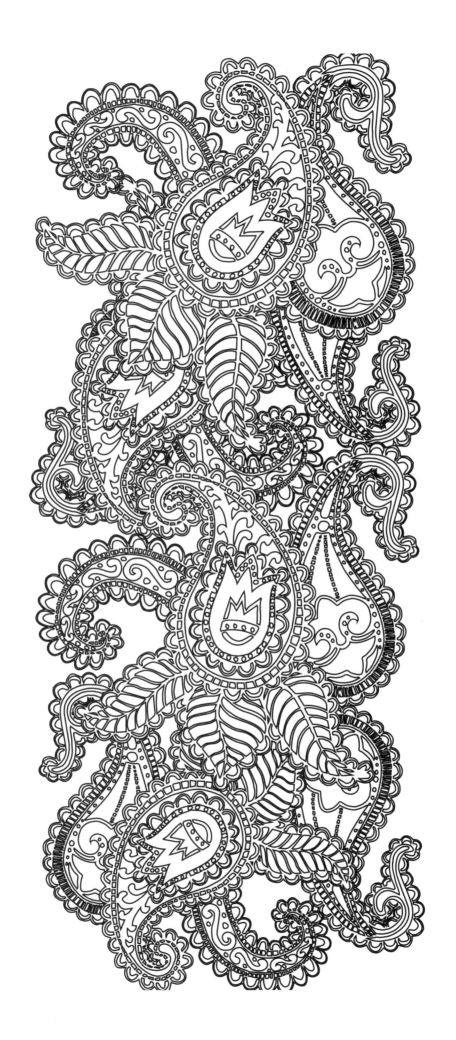

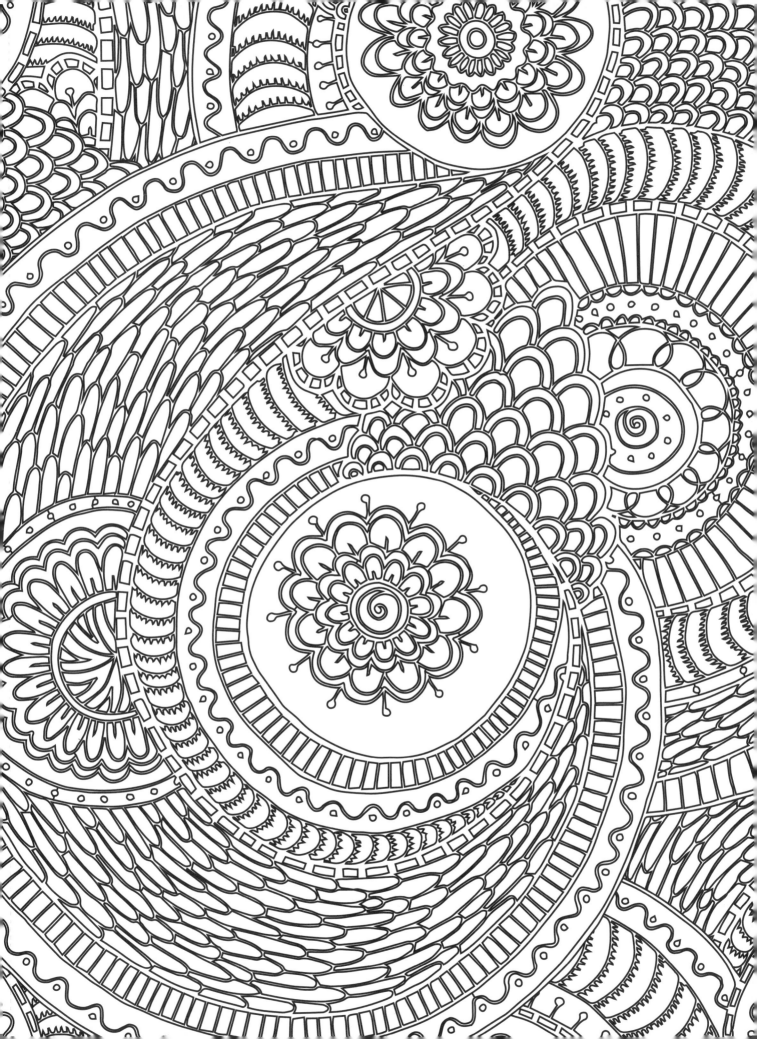

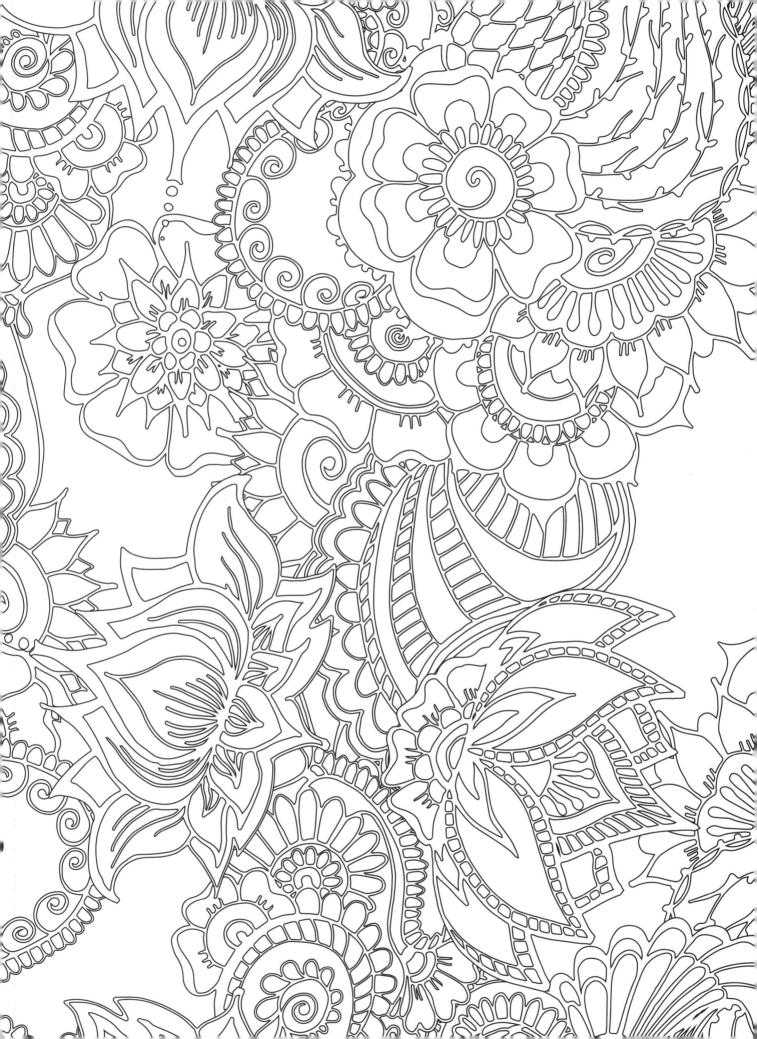

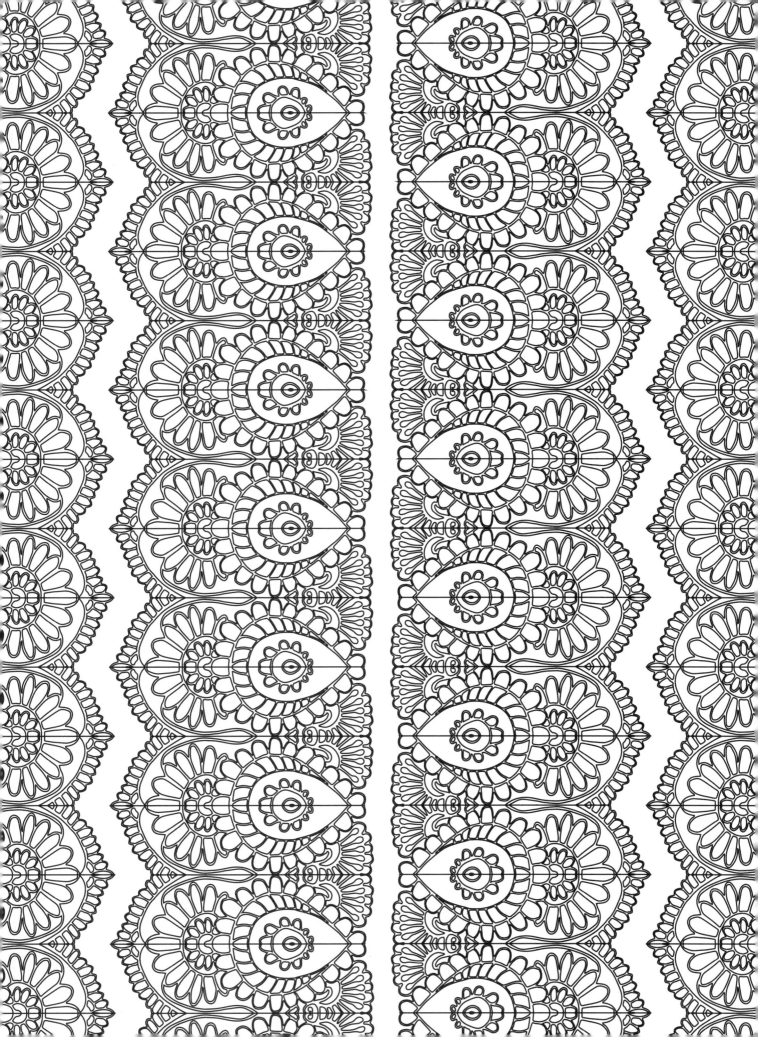

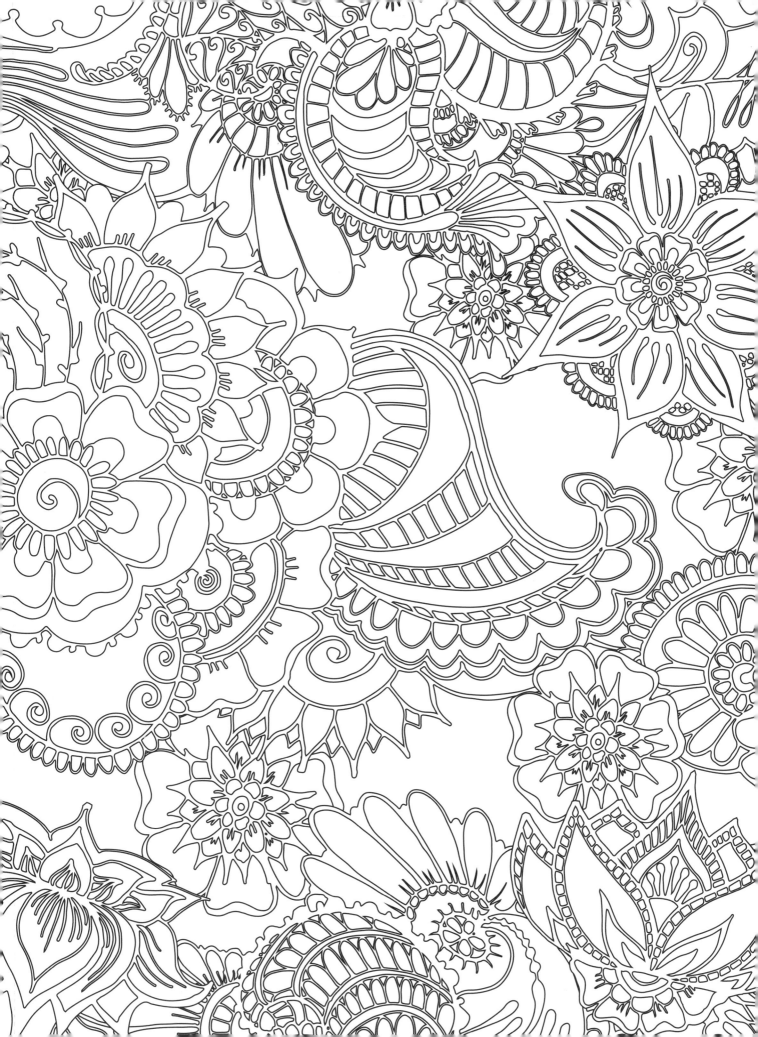

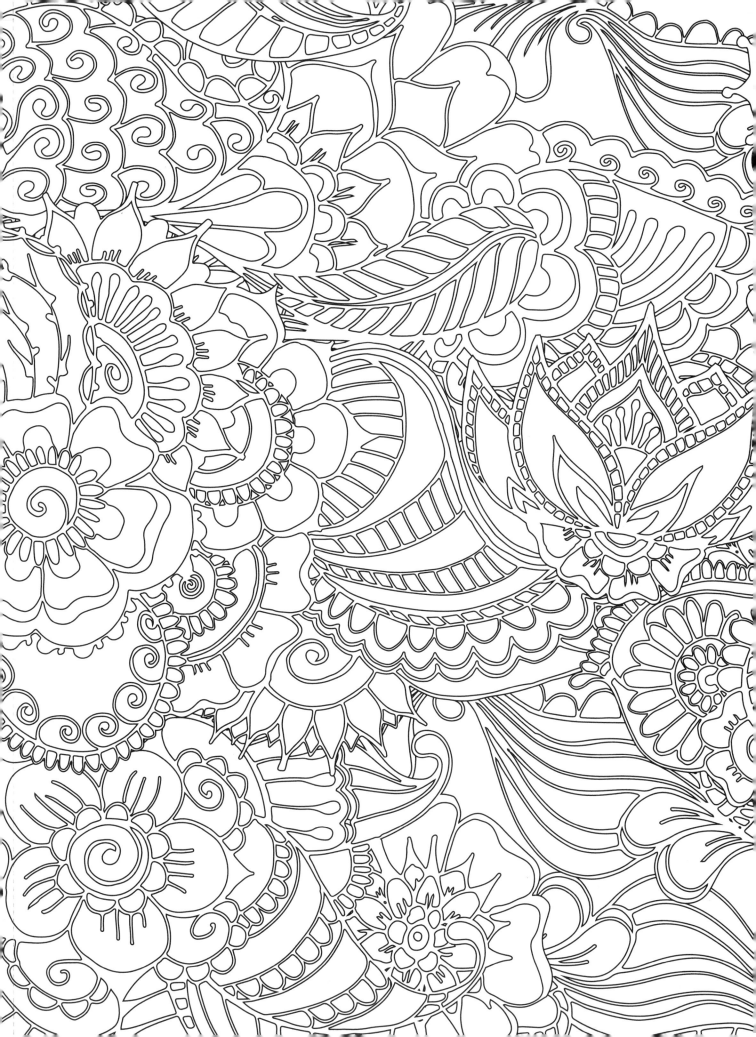

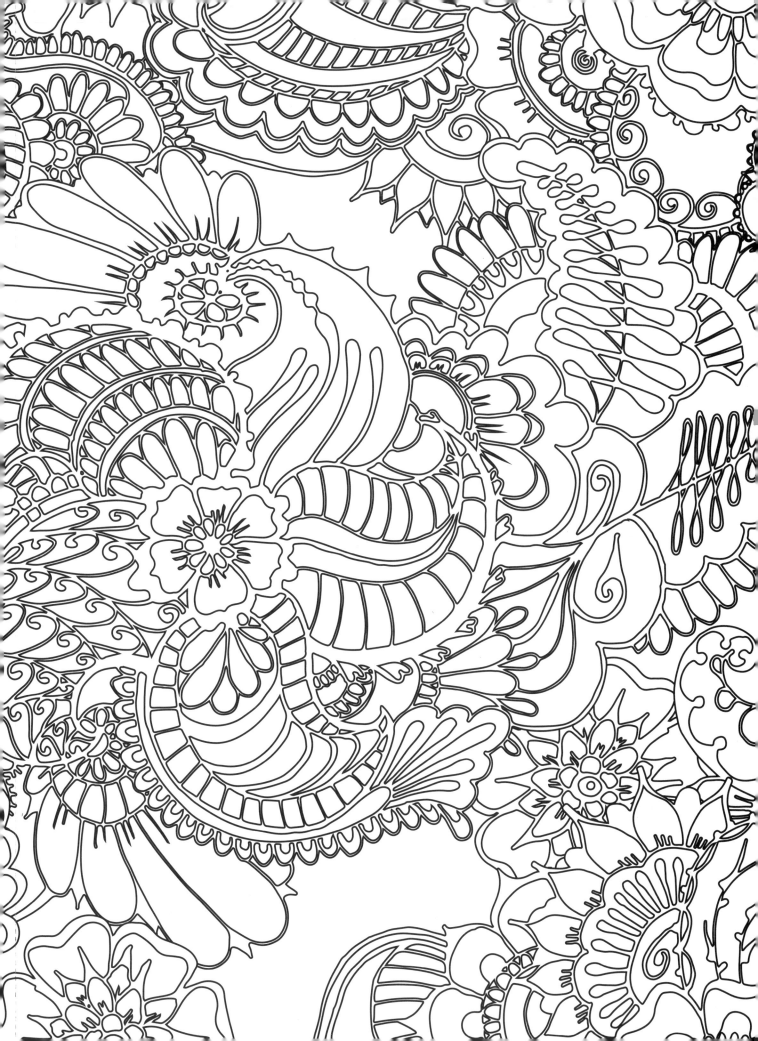

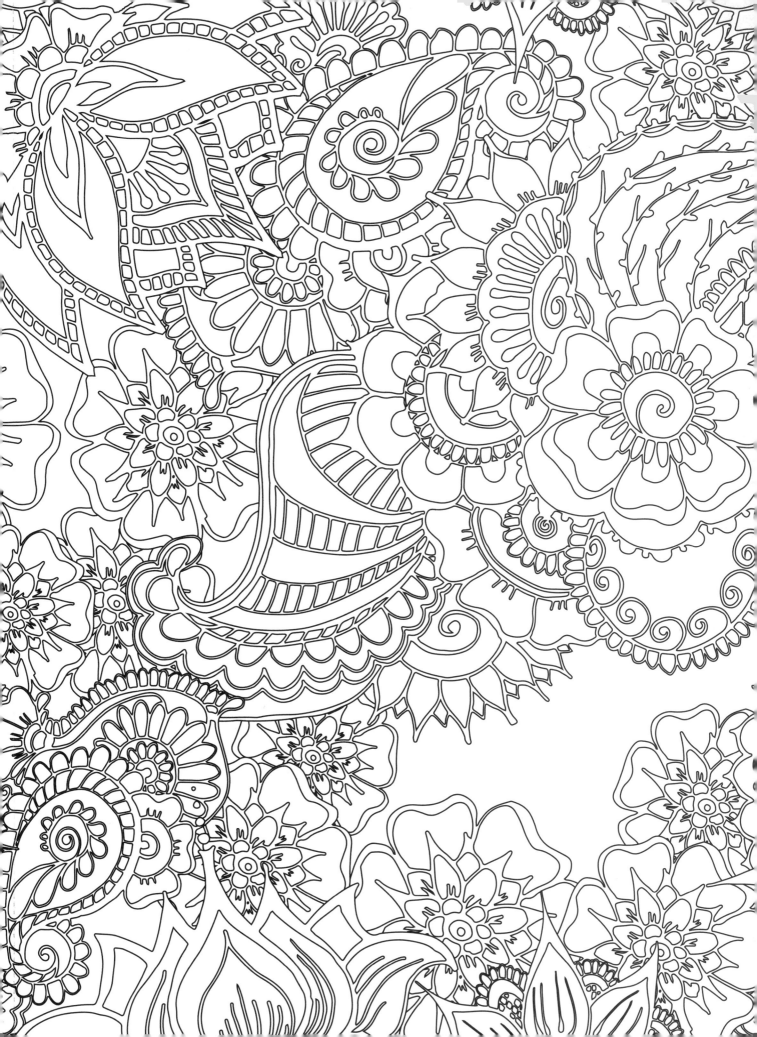

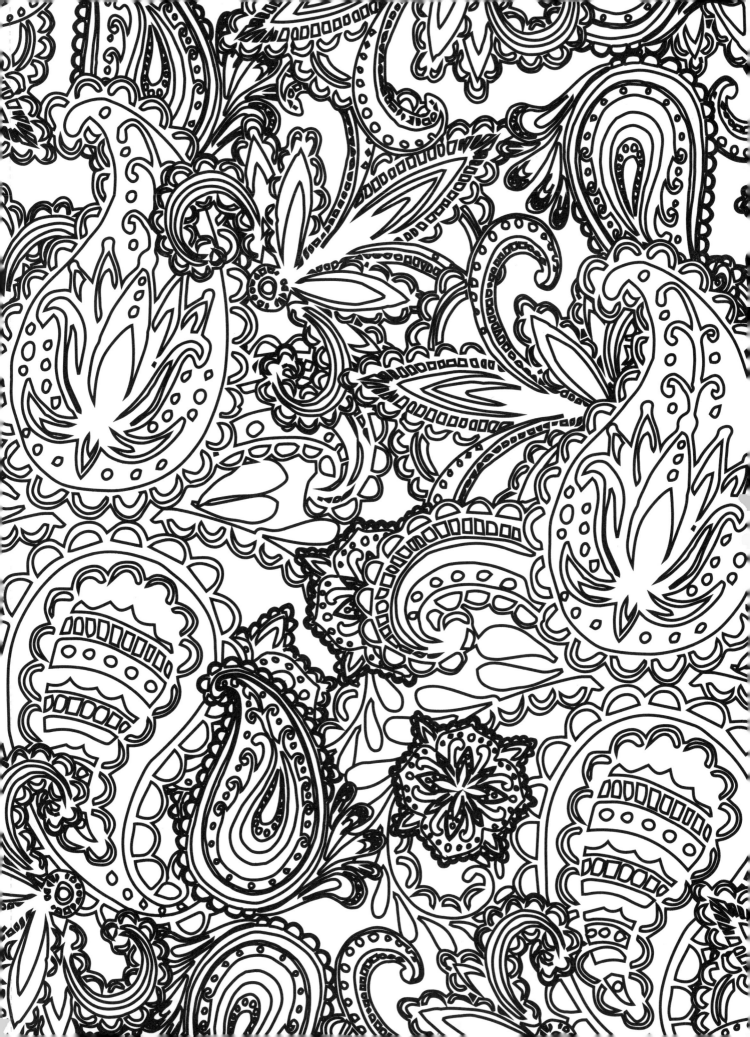

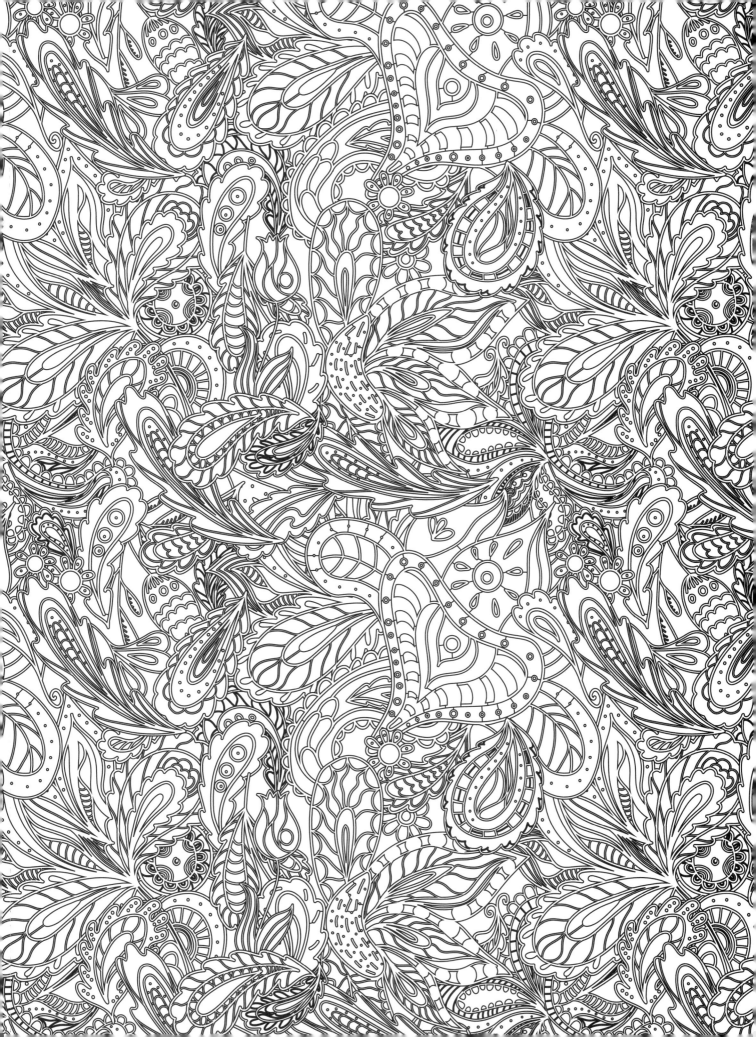

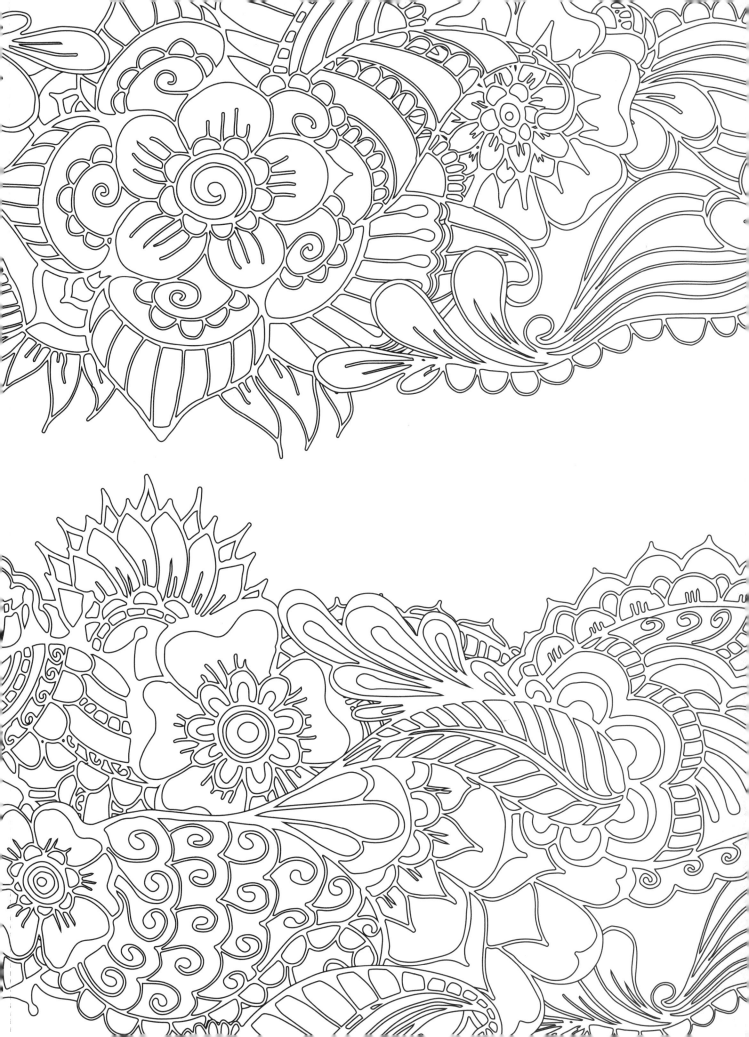

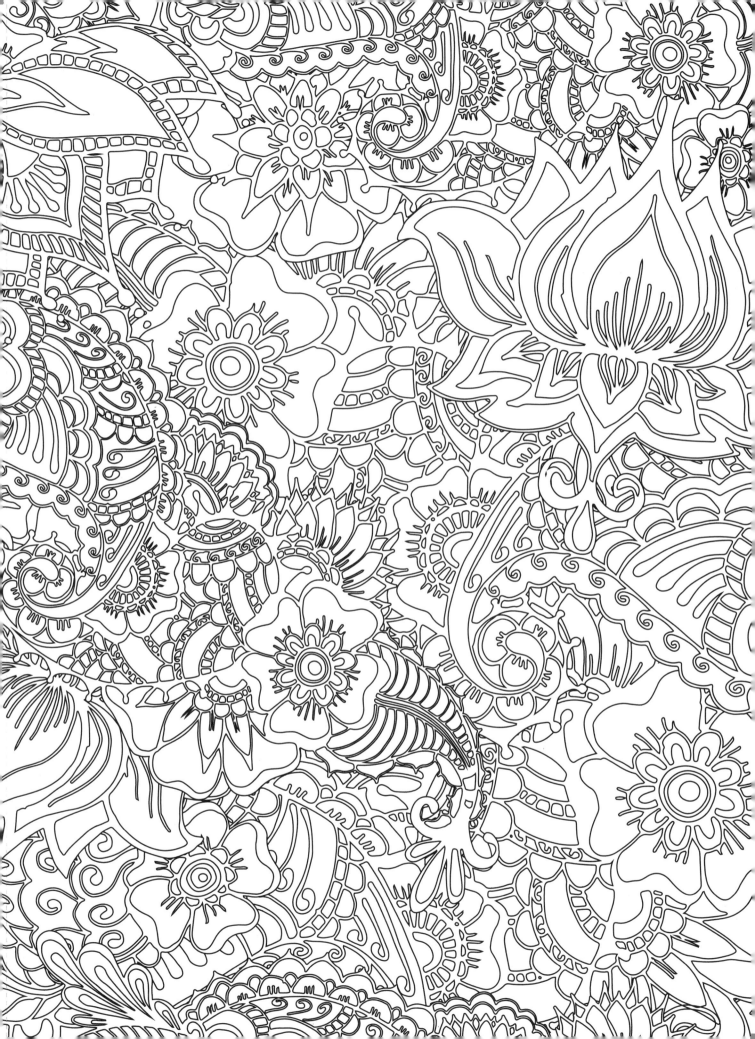

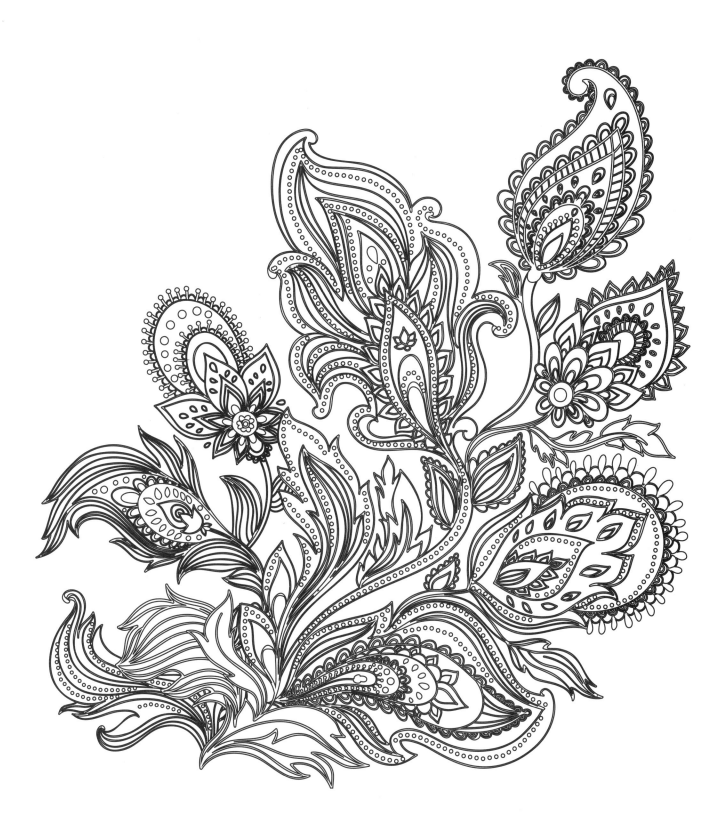

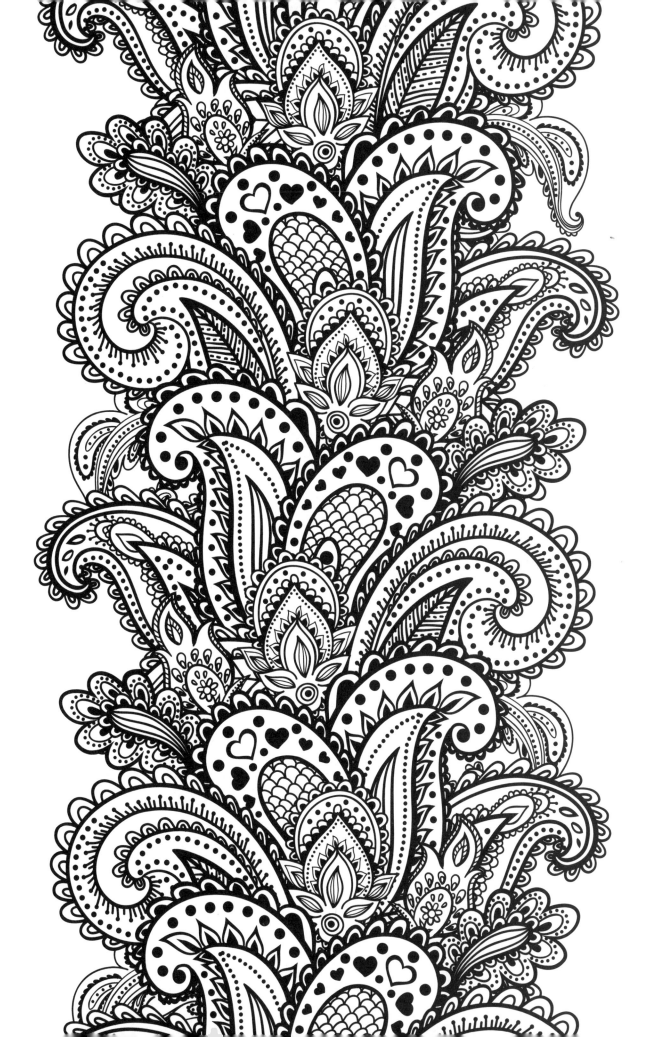

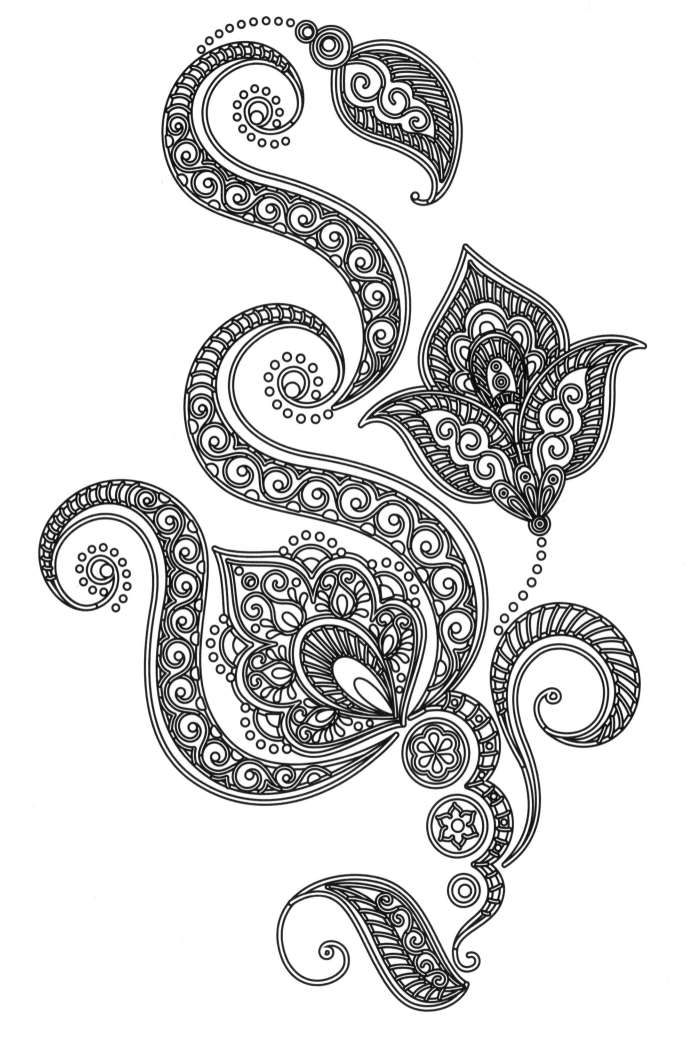

Color Bars

Use these bars to test your coloring medium and palette. Don't be afraid to try unique color combinations!

Color Bars

Color Bars

Color Bars